POSTCARD HISTORY SERIES

Aurora

On the front cover: This postcard is of the entrance to Fox River Park in Aurora. (Courtesy of Bob Arundale.)

On the back cover: Please see page 14. (Courtesy of Bill Catching.)

POSTCARD HISTORY SERIES

Aurora

Jo Fredell Higgins

ARCADIA
PUBLISHING

Published by Arcadia Publishing
Charleston SC, Chicago IL, Portsmouth NH, San Francisco CA

Printed in the United States of America

Library of Congress Catalog Card Number: 2006924328

For all general information contact Arcadia Publishing at:
Telephone 843-853-2070
Fax 843-853-0044
E-mail sales@arcadiapublishing.com
For customer service and orders:
Toll-Free 1-888-313-2665

Visit us on the Internet at www.arcadiapublishing.com

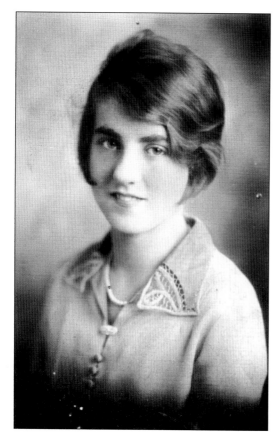

This book is dedicated to my beloved
Aunt Helen Melissa Scherer shown in this
c. 1932 photograph at age 20. One love,
two spirits, two lives together forever.

CONTENTS

ACKNOWLEDGMENTS

Pink hydrangeas in my summer garden sat beside the blue lobelia and yellow daisies. Their beauty gave me pause to reflect. In the west, a rosy sunset filled the horizon. All Saturday I had been writing this history of Aurora and it pleased me. Just as the flowers, just as the city itself.

The distinguished names of those who contributed to *Aurora* are many. John Jaros, Dennis Buck, and Jennifer Putzier from the Aurora Historical Society provided valuable support and collaboration. The Aurora Savings postcards, the cover of Dennis Buck's book, the West Aurora School postcards, and the Zouave images originally came from the Aurora Historical Society's Collection. Grateful thanks also to Mayor Tom Weisner, Bob Arundale, Tom Bartlett, Bill Novotny, Pat Sabin, Diane Christian of the Aurora Public Library, Bill Catching, Suzanne Higgins, Tom and Rose Deisher, Katie Brennan at Marmion, Cathy Voaden, Julie DeNood, Ivan Prall, Anna Morales, Bruce and Claire Newton, superintendent Dr. James Rydland of West Aurora Schools, Jay Harriman, curator David Lewis of the Aurora Fire Museum, Bruno Bartoszek, Ruth Mary Woods, Ken Kimmell, Danielle Kibling, Donna Christian, director Jan Mangers of Aurora Preservation Commission, Bert Swanson, Kathy Breazeale, Gladys Mason, Meta Mannion, Erv and Charlotte Gemmer, Mary Kies Kramer, Marisa Happ, Judy Kenyon, Bert Swanson, Dave Listern, Kathy Breazeale, Darla Cardine, Sarah Dwinnells, Dave Scharenberg, Rhea Hunter and the Todd Library at Waubonsee Community College, Jeff Scull, Joyce Kenyon, Maureen Granger, Joe Behm, Kenneth Heinze, John E. and Harriet Hurt, Ron and Carolyn Roesner, Bob James, Kirk Harding Jr., Judy Royer, Lynn Benesh, Caryl Huntoon, and Bob Novak.

In this postcard pictorial of Aurora, you will sense a spirit of place, of those who have come before. In 1859, ground was broken for city hall on Stolp Island. The basement was finished in 1860, but a contract for completion of the building was not let until 1864. There were wooden sidewalks and wood-lined streets. In 1900, Lake Street and to the west in the vicinity of Palace Street was all forest land and an old apple orchard. Progress and technology has brought the city to today. Aurora is now the second-most populated city in Illinois. To quote a song by Ken Hicks, "This is a song for all the good people. All the good people I've known in my life. This is a song for all the good people. The people I'm thanking my stars for tonight."

INTRODUCTION

Early permanent white settlers of the Fox River valley area included Mr. McKee, a blacksmith who wandered west from Chicago in 1833. The earliest settlers in Aurora Township were Joseph Carpenter, who moved from Ohio to Chicago in November 1832, and to near Montgomery in December 1833. His father-in-law, Elijah Pierce, followed in early 1834, just before Joseph McCarty. Joseph McCarty arrived in April 1834. He was born on January 24, 1808, in Morristown, New Jersey, of Scotch-English ancestry. His brother Samuel was born on March 9, 1810. Joseph, a 25-year-old millwright, left his home on November 25, 1833, accompanied by an apprentice, Jeffrey Beardsley. On April 1, 1834, they paddled up the Fox arriving at the Native American village of Waubonsie, just one mile north of the present downtown Aurora. This area was included in the tract 10 miles square that had been a Native American reservation. Joseph staked a claim of about 360 acres on the east side of the river. He erected a small 10-by-12-foot log cabin. Later he purchased a claim of 100 acres on the west side of the river. Joseph had wanted to secure unquestioned rights to the waterpower. He built a sawmill and dam nearby, extending from the east bank to the island. By this time, brother Samuel had settled his business out East so he could join Joseph. An old account book shows that the first sawing at the mill was for Mr. Wormley of Oswego. The date was June 8, 1835.

During the winter of 1835–1836, the McCartys laid out the original plat of the village. About 40 settlers had arrived this first year. Joseph McCarty had spent many hours in the cold river water building the dam, and he suffered a hemorrhage of the lungs. He was advised to go south to Alabama for his health, but death called on him there one month later in 1839.

The village had no official name but was called McCarty Mills. Amos Kendall, postmaster general under Pres. Andrew Jackson, appointed Burr Winton as the first official postmaster. When a post office was established in 1837, it became necessary to give the town a name. Elias D. Terry, a McCarty cousin, was quoted as saying, "It would be well for us now to consider the significance of the home of our city (a rising light) and labor to make it worthy of the beautiful and classic title." And so, the official name became Aurora in 1837.

Thus it was, thus it began—Aurora, the "City of Lights," freighted with destiny, strengthened by ethnic diversity, enriching and evolving. I welcome you to this postcard history.

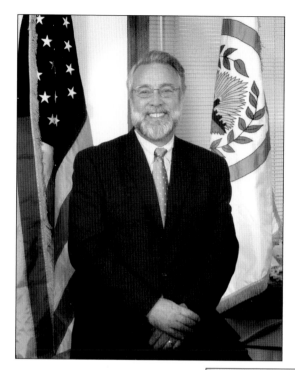

Tom Weisner was elected mayor of Aurora on April 5, 2005. His inaguration was celebrated on April 25, 2005. (Courtesy of Mayor Tom Weisner.)

City of Aurora

Mayor's Office • 44 E. Downer Place • Aurora, Illinois 60507-2067 • 844-3612 • FAX 892-8967

Thomas J. Weisner
Mayor

Dear Reader,

In the 1936 City Directory we read that Aurora is *the* "garden spot" of song and story, coupled with a present-day modernism that creates a civic ideal. Winding through its charming valley from the North, the river divides at the very center of the city to form an island. Beautiful bridges, "symphonies in stone and steel" link the island to comfortable homes…homes and gardens where life offers contentment and peace. This is Aurora, the "City of Lights."

Aurora was the birthplace of the Burlington Railroad in 1851. On September 20, 1854 Aurora held the first convention under the name "Republican Party". It nominated James H. Woodworth of Chicago for its representative in Congress. In 1881 Aurora was the first city in the world to have an electric street lighting system. It is to this city of recorded industry and merit that I welcome you. This postcard history of Aurora was written by noted author Jo Fredell Higgins. With her thoughtful weaving of the past with the present, this portrait of Aurora is truly outstanding.

With best regards,

Tom Weisner
Mayor, City of Aurora

printed on recycled paper

One

A JOURNEY LIES WITHIN

Truth is discovered backwards, fact buried in the flow of impression, in the stories told then and now.

—Katherine Govier (1938–)

The first commercial enterprise in Aurora was the McCarty sawmill, which began operations on June 12, 1835. Z. Lake built two sawmills on the west side in 1837, and this mill changed hands several times thereafter before it ceased operations in 1875 when it was destroyed by fire. The mill could turn out 200 barrels of flour a day with its five "run" of stone. The Aurora Woolen Mills, owned and operated by J. D. Stolp, was one of the most important establishments in the early days of Aurora. He continued the manufacture of woolen cloth of the finest quality until 1887 when all the machinery was sold and the building was rented to several smaller manufacturers. George McCollum built the first plow and wagon factory in 1837. The name McCollum represented quality farm implements. Various smaller industries included Wright and Company, a sash and door factory that began in 1843; Aurora Brewery, which began in 1855 by Gottfried Egger; and the Aurora Soap Factory, which began operations in 1856 by Mr. Beach and O. N. Shedd. The Eitelgoerge Brothers of 28 North LaSalle Street were dealers of fine cigars and tobaccos. Kane County was one of the early manufacturing centers in Illinois, producing goods worth $4 million in 1870. Primarily an agricultural state, Illinois industry began emerging in the post–Civil War era as new markets opened for all manner of consumer goods.

Brief facts about Aurora in 1910 show six banks, five parks, three theaters, three daily newspapers, 42 churches, and 26 schools. A writer of that time suggested that Aurora "has a quiet resident people, an order-loving population, a cultured and refined people." There were 60 passenger trains from Aurora to Chicago in 1910 as well as 14 lines of steam and electric railroads radiating from Aurora. City hall had cost $100,000 to build, and the post office had cost $130,000. Population had grown to 35,000 by 1910 with 35 miles of paved streets. There were 15 firms devoted to the manufacture of women's apparel, employing over 1,500 persons. The products included corsets, underskirts, cotton goods, shirtwaists, wrappers, and kimonos.

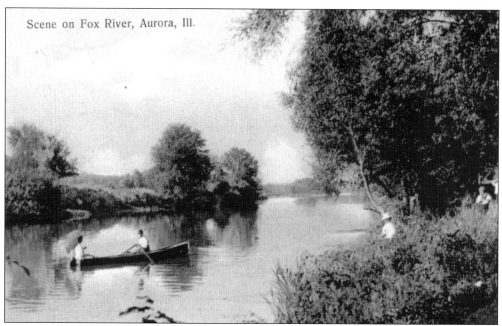

Scene on Fox River, Aurora, Ill.

Weaving through the rich tapestry of Aurora's history is the Fox River. According to an account by Samuel McCarty in the *Aurora Beacon*, "It has been forty-one years since I set foot on the beautiful banks of the Fox River. At the place where Aurora now stands, I found but one log cabin." Another description of Kane County states that the "whole range of the Fox River is thickly settled. Dams are thrown across the Fox River in five places and saw-mills erected." This postcard was mailed on October 15, 1906. (Courtesy of Bob Arundale.)

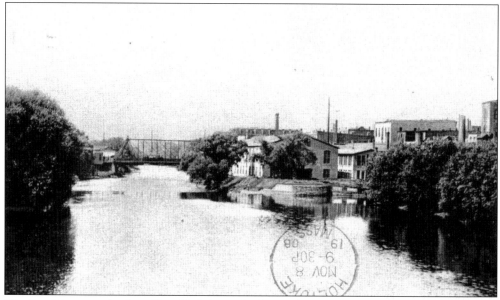

The Fox River, south of the New York Street bridge, is shown in 1908. To the east, the Fox ran in a winding path from Dundee to Aurora, its waters uninterrupted by any bridge or dam and everywhere wider than present. Along its shores were abundant groves of oak and other trees. The land was largely black soil with some clay, sand, and gravel. (Courtesy of Bill Catching.)

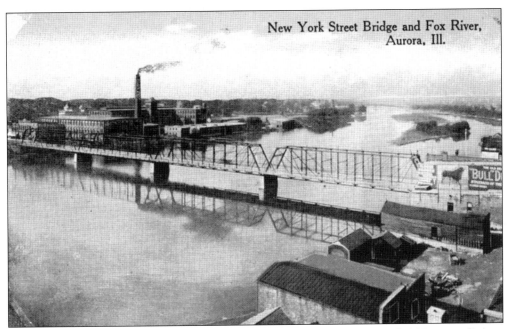

New York Street Bridge and Fox River, Aurora, Ill.

Shown here is the New York Street bridge and river scene. The pioneers of 1907 were religious with sincerity, placing confidence in that providence that attends to the fall of the sparrow as with the lives of men. Society in Kane County was distinguished for good citizenship and well-ordered government and activities. (Courtesy of Bob Arundale.)

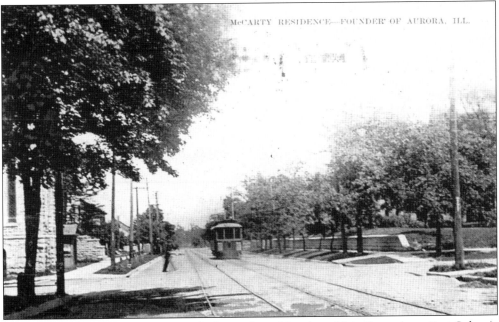

McCARTY RESIDENCE—FOUNDER OF AURORA, ILL.

Dated November 29, 1909, this view looks north on Lincoln at Main Street (now East Galena), near the Samuel McCarty residence. Many homes combined the kitchen, parlor, and bedroom into one room. The house was a haven of rest where existed all that was best on earth. There were born and bred some of the noblest women, the greatest of men. (Courtesy of Bob Arundale.)

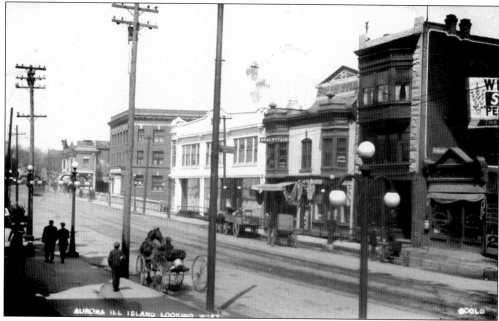

This view looks west on the island in 1912. Could the melodious sounds of a violin or dulcimer be heard this day? A writer in 1910 suggested that Aurora was a recognized center for students of music. There were choral societies, church choirs, and a music conservatory with 20 teachers and more than 500 students enrolled in the different music classes. (Courtesy of Bob Arundale.)

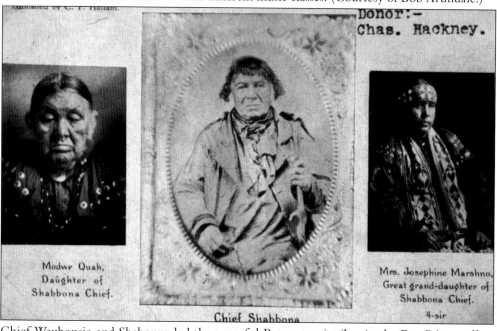

Chief Waubonsie and Shabonna led the peaceful Potawatomi tribes in the Fox River valley. Waubonsie (1765–1848) was born in Indiana, a younger brother of Black Partridge. Waubonsie's village was located in the Grand Bois, or "Big Woods," below Aurora on the Fox River around the 1820s. Shabonna, a friend of the white man, died in 1859 at the age of 84. He was buried at Morris. (Courtesy of the Aurora Historical Society.)

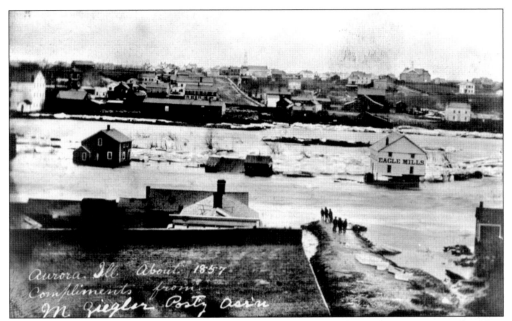

Theodore Lake laid out the village of West Aurora in 1842. In 1851, the year that the railroad was completed to Aurora, there were four land additions made to the villages. The first bookbindery in Aurora was established in January 1856 by J. H. Hodder. Winslow Higgins took up residence about this time. John McInhill established a distillery on the west side of the river in 1849. (Courtesy of the Aurora Historical Society.)

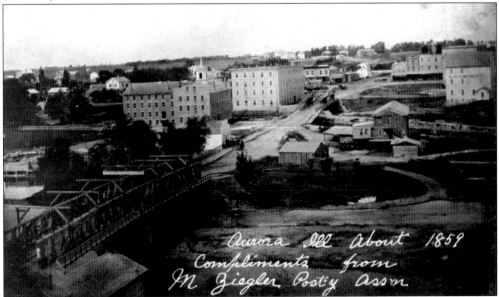

Improvements in Aurora in 1859 included a wagon shop built by Chandler and Westcott at a cost of $1,100 and a $20,000 building built by J. D. Dunning. It contained four stores, each 22 by 80 feet, five stories high, including basements and white stone front, and bush-hammered with rustic joints. The architect J. A. Hinds commented that this building was "unsurpassed in elegance west of Chicago." J. D. Stolp's addition to his woolen factory cost $8,000 that year. (Courtesy of the Aurora Historical Society.)

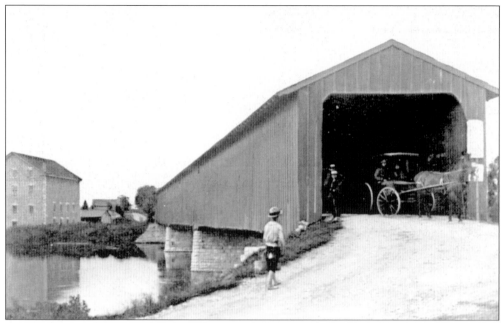

This covered bridge in Aurora was dismantled and rebuilt in Montgomery in 1868. It was removed in 1915. One of the main reasons for covered bridges was to keep rain and snow and other elements off the timbers and, thus, add more years to their life. It also prevented horses from shying at the running water below. The oldest covered bridge in the world is located in Switzerland and was built in 1333. (Courtesy of Bill Catching.)

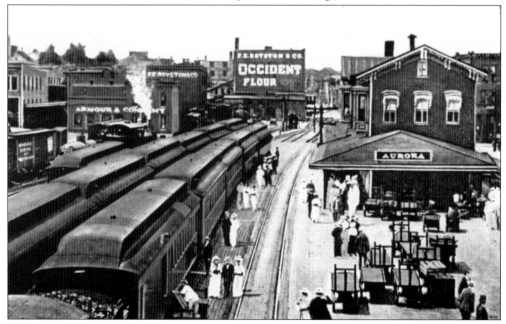

With a population over 1,000 in 1848, local leaders began talking about a railroad. On February 12, 1849, a charter for the Aurora Branch Railroad was granted. This old Chicago, Burlington and Quincy Railroad depot stood at LaSalle and New York Streets from 1866 until 1922. This postcard is from around 1908. (Courtesy of Bill Catching.)

Joy Tarble built this home located at 453 Plum Street in 1887. The house behind it belonged to Albert Tarble, captain of the Aurora Zouves. The house next to it was built by Joy Tarble for his only daughter Elizabeth when she married Arthur Avery. Joy Tarble is shown seated in front of his home. (Courtesy of Maureen Granger.)

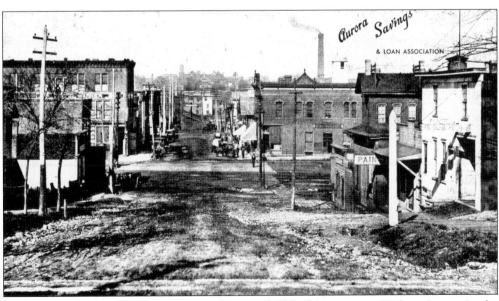

Shown in this postcard is the New York Street hill looking west to Walnut Street. In the background is the Oak Street School belfry. Notice the Chicago, Burlington and Quincy tracks and the depot to the right. This postcard is from around 1895. (Courtesy of Bill Novotny/Aurora Historical Society.)

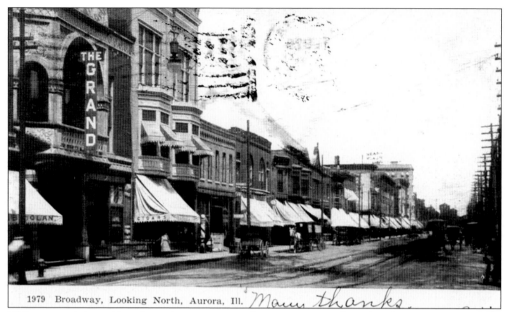

1979 Broadway, Looking North, Aurora, Ill. *Many thanks.*

This postcard shows Broadway Street in 1907, the year Aurora's first chamber of commerce was established. Also that year, the Maytag hand-cranked washing machine was replaced by the ultramodern electric Hurley. A motor-powered machine that vacuumed dirt into a bag was also introduced by Hoover in 1907. (Courtesy of Bob Arundale.)

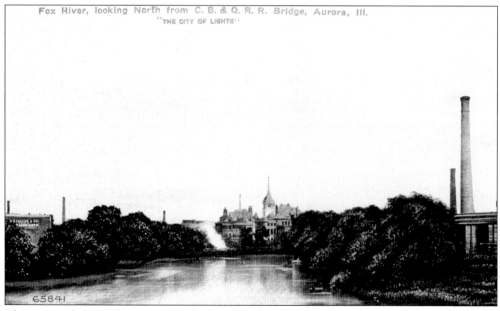

Fox River, looking North from C. B. & Q. R. R. Bridge, Aurora, Ill. "THE CITY OF LIGHTS"

This postcard shows the Fox River looking north, and was postmarked on October 30, 1907. The city directory listed Aurora's population in 1908 as 30,265. There were nine Higgins family residences. Ed Higgins was a blacksmith. Others listed by name include Katharine, Frank, Mary, Michael, Nellie, and Thomas Higgins. (Courtesy of Pat Sabin.)

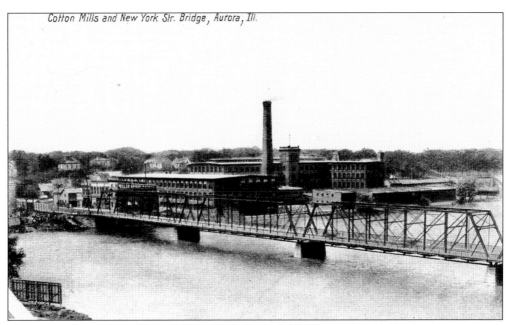

Shown are the cotton mills and New York Street bridge around 1908. At that time, Aurora had a broom manufacturer, carpet weavers, 19 boarding hotels, three corset manufacturers, 59 dressmakers, nine hotels, a sanitary bathroom for massage and Turkish baths by J. G. Turner at 32 Fox Street, two midwives, 12 milliners, as well as painters, paperhangers, and piano tuners, plus 48 saloons. (Courtesy of Pat Sabin.)

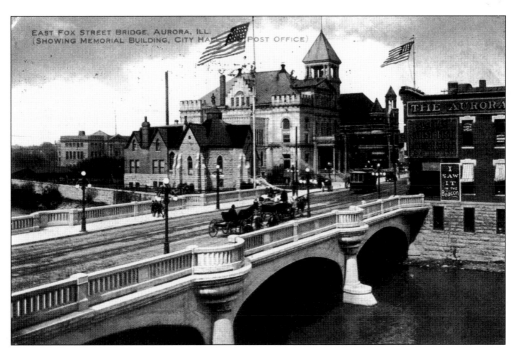

Memorial Building, Aurora City Hall, and the post office are shown in this beautiful postcard that was mailed on August 10, 1910. (Courtesy of Bill Novotny.)

Harold Roesner is shown in 1907 at two years of age. The first Roesner to arrive in America was August, who came from Germany to Aurora in 1847. He was listed in the city directory of that year as a German-speaking male of 23 who lived on Benton Street and was a teamster. Harold was the great-grandson of August. (Courtesy of Ron and Carolyn Roesner.)

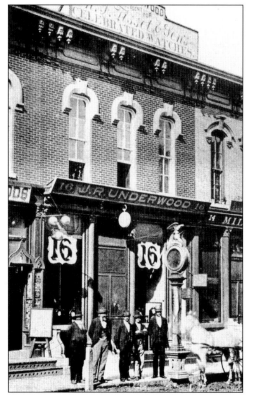

Prof. Frank Hall invented the world's first electric clock, as shown on this postcard. It was located in front of J. R. Underwood's store at 16 Fox Street in Aurora. Underwood's was established in 1856 and was a dealer in fine watches and jewelry and a silver plater. He sold the celebrated Tissot watch, clocks, spectacles, gold pens, and cutlery. From 1880 to 1900, he was a traveling salesman for Aurora Silver Plate Manufacturing Company. (Courtesy of Bill Novotny/Aurora Historical Society.)

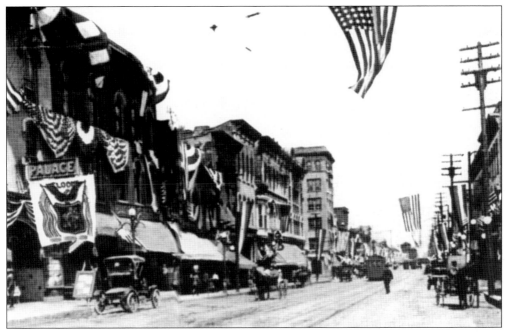

Imagine that it was a warm day in September 1909. Visitors to Aurora would notice the many American flags that welcomed them to the Labor Day parade. Local delivery wagons passed by quickly with their loads of groceries or lumber. A bakery with a dining room on Broadway Street offered breakfast, including a choice of meat for 15¢. The city treasury had a balance of $29,794.87, and alderman Fred Fauth, a candidate for mayor, was the chairman of the finance committee. (Courtesy of the Aurora Historical Society.)

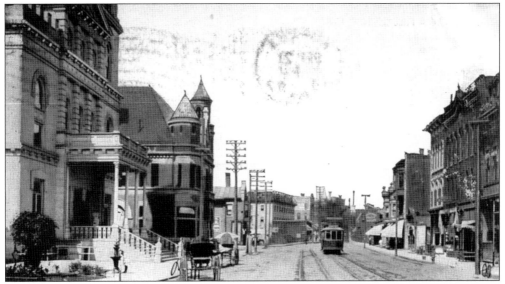

On September 21, 1907, this postcard was mailed to Tilly Towler with the message, "Just arrived this evening and am fine and dandy." It was signed Loretta. In the late 1800s, children in the family might have collected milkweed pods that autumn and their mother would spin the soft silky substance from the pods into candlewicks. Beef fat was boiled until it was ready to be made into candles. Each family would need candles for the deep winter nights. (Author's collection.)

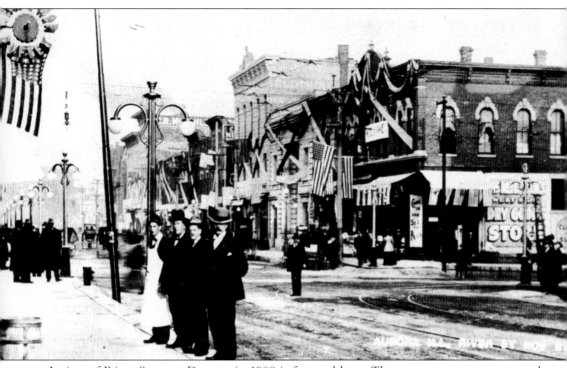

A view of River Street at Downer in 1908 is featured here. The open streetcars transported customers and visitors in an orderly fashion and with a commanding view of the passing scene. A writer later penned that "Aurora is a happy city, provided with all that makes life desirable, in a setting of beauty that has made the Fox River Valley famous." (Courtesy of Bill Catching.)

Two

THE AURORA STORY

Everything mortal has moments immortal. Swift and God-gifted, immeasurably bright.
Joy in the touch of the wind and the sunlight! Joy! With the vigorous earth I am one.

—Amy Lowell (1874–1925)

Alluvial valleys and arable and productive land greeted the settlers of Aurora Township. The valley, stream, and prairie of 1834 smiled over the surrounding fields and saw future farmhouse, granary, mill, and village. What had been home for the Native American was to be cultivated by Jacob Carpenter, Elijah Pierce, William Elliott, the McCartys, and others soon to follow. In 1836, Winslow Higgins hired an acre of land and planted potatoes. He agreed to take three-quarters of the crop as his share. That share amounted to 300 bushels. The Chicago, Burlington and Quincy Railroad shops had been established after 1856 and employed 2,500 workers just before World War I. In those days of simple habits and honest industry the city flourished. In 1857, in accordance with the wishes of the residents of East and West Aurora, William R. Parker, then their representative in the state legislature, procured the passage of an act incorporating the two villages under one charter as the City of Aurora. The date was February 11, 1857, and Aurora's population was 7,000. Aurora Silver Plate Manufacturing Company had organized in 1869. It employed 65 workers who produced silver-plated holloware, Britannia metal, Queen's metal, and tin goods of every design and description. The first municipal election under the charter was held in March 1857 and resulted in the election of B. F. Hall, for mayor and Holmes Miller, R. C. Mix, J. D. Clark, L. Cottrell, W. V. Plum, J. B. Stolp, S. L. Jackson, and William Gardner for aldermen. By 1872, the population of Aurora was estimated to be 12,761. It was a city now "full of life and business."

Until the 1870s, Aurora's northern boundary was the Burlington tracks. An aerial perspective made in 1882 shows 35 homes north of the tracks—an area called Pigeon Hill. The area received its name because a neighbor living near High and Edwards Streets had a large pigeon loft. The highest point of the area, the sharp elevation from the river made the hill more noticeable then. People traveling on North Broadway Street, seeing the large flocks of pigeons around Edwards's loft, named it Pigeon Hill.

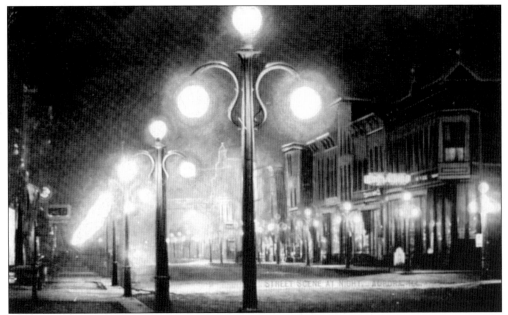

A beautiful River Street scene in 1908 shows the City of Lights. Western United Gas and Electric Company had lit the streets in 1868. By 1881, the contract expired and Aurora installed a system of electric streetlights, the first in the world. The Brush arc light had just been perfected, and L. O. Hill, who operated a sash factory on South Broadway Street, started a business in electrical production. Clusters of electric lights were scattered throughout the city on steel towers 150 feet high. (Author's collection.)

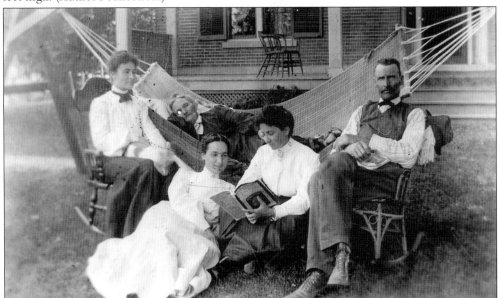

Seen here, from left to right, Aunt Kitty Ingham, Gramma, Sara, Mildred, and grandpa Joe Ingham relax around 1890 at the farm on Galena Road. By 1880, the city was entirely out of debt. Evidence of refinement and prosperity could be seen along the avenues and boulevards, whether business or residence. The German apothecary as well as the merchant tailor and general clothier prospered. Honorable conduct was its own reward. (Courtesy of Myron Nelson.)

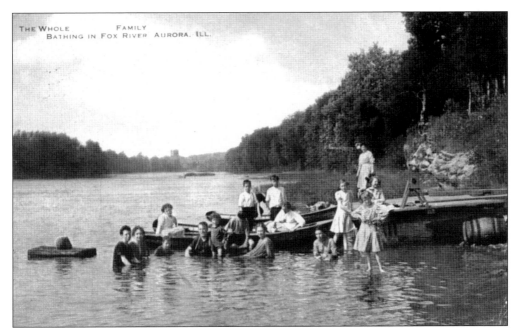

The temperature was rather mild with a high of 62 degrees on August 12, 1912. This postcard shows some family members bathing in the Fox River. The *Aurora Daily Beacon* had a circulation of 12,000 in 1910. A quote from a large Chicago advertising agency related, "There is no other paper in Illinois that I know of that covers its territory as thoroughly as does the *Aurora Daily Beacon*."(Courtesy of Meta Mannion.)

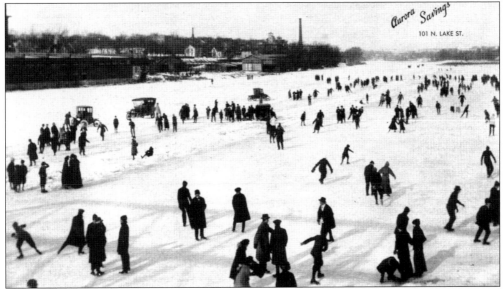

On a wintry Sunday in 1915, residents enjoy skating on the Fox River. The Fox River was the source of power needed to grind grain and convert growing timber into homes, schools, and churches. The first settlements in the county had clustered around waterpower developments. Ice-skating had gained popularity in the mid-1800s as a way to enjoy the wintertime, and an 1866 issue of Frank Leslie's *Illustrated Newspaper* deemed ice-skating as "our national winter exercise." (Courtesy of Bill Novotny/Aurora Historical Society.)

The earliest known exposition card appeared in 1873, showing the main building of the Inter-State Industrial Exposition in Chicago. This card, like other early advertising cards, was not originally intended as a souvenir. The first card printed with that intention went on sale in 1893 at the Columbian Exposition in Chicago. Government-printed penny postcards were mailed frequently to friends and family. This card was mailed in December 1914. (Courtesy of Bob Arundale.)

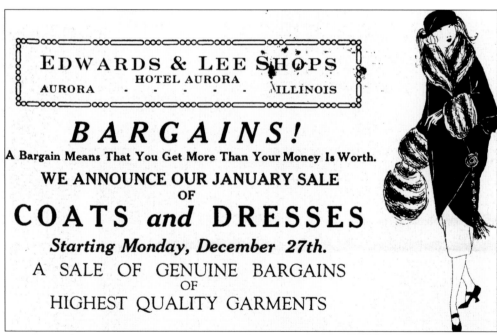

An advertising postcard from around 1925 for the Edwards and Lee Shops in the Hotel Aurora appears here. Chrysler Corporation was founded in 1925. A six-cylinder luxury car sold for $1,500. The previous year, George Gershwin's *Rhapsody in Blue* was billed as an "experiment in modern music." In 1927, Charles Lindbergh endured fog, sleet, and exhaustion during his nonstop 3,600-mile cross-Atlantic flight and landed in Paris to a hero's welcome and $25,000 prize. (Courtesy of Bob Arundale.)

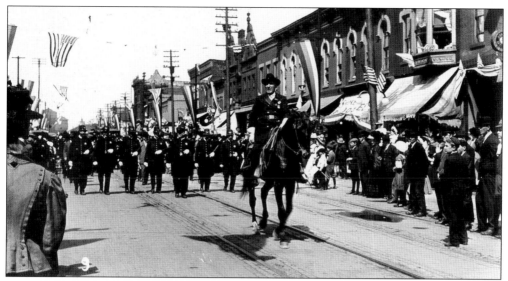

Moonlight, still as paint, shone over Aurora the evening of the parade in 1909. It was a time of crochet, capelets, chemise, and cash and carry. At the Grand Opera House of Aurora, which had been built in 1891, the comedy sensation *Girls* was playing for 25¢ a ticket. *Aurora Daily Beacon* want ads were 1¢ per word. Words in vogue included "coterie," "rueful," "ebullition," and "demurred." This was the postcard scene of the Grand Army of the Republic parade in 1909. (Courtesy of Bob Arundale.)

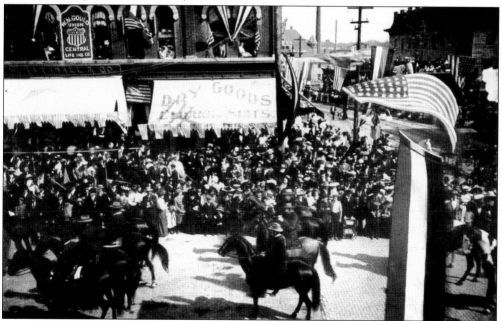

This postcard shows the May 19, 1909, parade at the state encampment. The Grand Army of the Republic Memorial Hall, Aurora Post 20, was completed in 1877 at a cost of $7,187.54 on land donated by one of Aurora's city fathers, Joseph G. Stolp. Over the course of the next 60 years, the post had a membership of more than 700 Civil War veterans, representing 70 Illinois regiments. The last surviving member of Post 20 was Daniel Wedge, who died in 1947 at the age of 106. (Courtesy of Bob Arundale.)

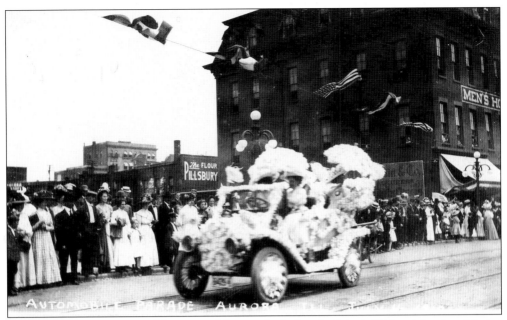

What an enchanting scene of the automobile parade during the July 4, 1910, celebration. Notice the hats! This parade was similar to the previous 1909 parade for the GAR. The Grand Army of the Republic was not only a patriotic organization but focused on rehabilitating and assimilating those who had served the country. The Grand Army of the Republic held state and national conventions, and Aurora was the location in 1909 for this event. Hundreds of lights illuminated an arch across Downer Place at night. Three soldiers stood guard atop the arch during ceremonies and the following parade. (Courtesy of Bert Swanson.)

After the Civil War, veterans from Aurora wanted to build a memorial to those who had fought in the war. The Grand Army of the Republic was formed in 1866. In 1869, 23 Aurora veterans started fund-raising activities to build a memorial structure. Post 20 of the Grand Army of the Republic was chartered on June 10, 1875. This handsome limestone structure at 23 East Downer Place has housed a vast collection of war memorabilia from the past and is included in the National Register of Historic Places. Shown is the Grand Army of the Republic Memorial Hall in 1991. (Author's collection.)

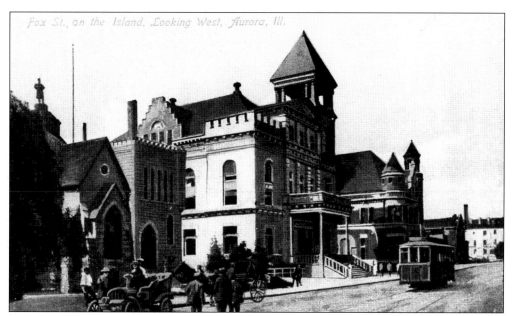

Octogenarian Henry Schoberlein lived in "Dutch Town" of Aurora all his life and recalled that in 1910 Aurora offered a 5¢ streetcar ride. He helped stove-fire it on the ride downtown so as not to freeze. Horse watering troughs throughout the city held 500 gallons of water. A wagon seller fixed umbrellas and sharpened knives and scissors. Another wagon business was run by a short Englishman with a beard who sold cottage cheese, sweet milk, buttermilk, and butter. This view shows Fox Street on the island looking west. (Courtesy of Bill Catching.)

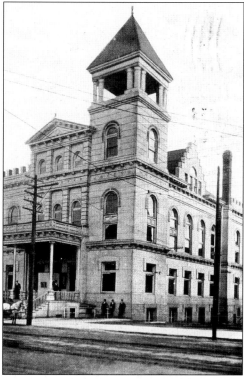

City hall, built between 1859 and 1866, is shown on this postcard mailed on June 29, 1909. Residents could stop at Mason's Bakery as well as Olinger Dry Goods Store while downtown. At Delson's Dress Store, a hat could be purchased that showed a miniature flower garden on top. The Manhattan Café offered complete lunch meals for 25¢. At Clayton's Jewelry Store, the potbelly stove offered heat to the men gathered there who played checkers. (Courtesy of Julie DeNood.)

FRANK WARD

CANDIDATE
FOR

Town Collector

ELECTION TUESDAY, APRIL 5, 1904

Kane County was Democratic during the first few years after its organization. During the presidential election of 1836, there were 235 Democratic votes cast and 93 for the Whigs. Heavy traffic existed in the Underground Railway throughout Kane County. Many assisted the runaway slaves to freedom, housing them and helping them to reach Canada. The Whigs were opposed to slavery. During the national convention in Philadelphia in 1856, the Republican and Whig Parties combined into one. (Courtesy of Bob Arundale.)

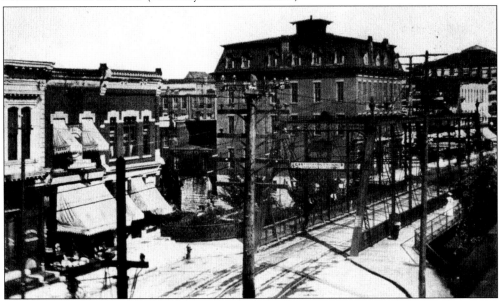

Shown is the old bridge that was dismantled in 1909. The view is east from city hall. The first bridge had been built by subscription in 1836. It was swept away by high water in 1837. At the beginning of 1857, there were three wagon bridges and all were gone by a great flood in February of that year. The wooden bridges were replaced by iron bridges in the autumn of 1868. (Courtesy of Bert Swanson.)

28

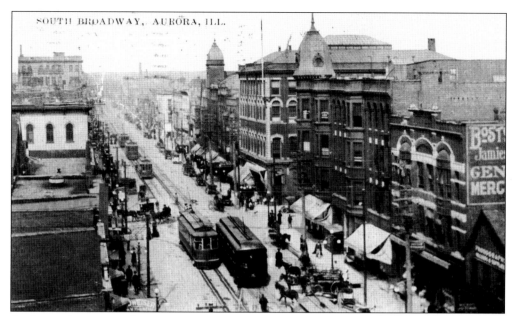

A vibrant downtown Aurora is seen in September 1910. The German word "viederholden" means "to think back." Fresh rye bread could be purchased from the Kuechel bakery, Ohlavers on Jackson Place sold the best ice cream, and Butch Hauser's meat market flourished because he knew how to treat customers. His wagon had a big bell so people would know when the wagon was out front. Hauser or one of his butchers would chop off a block of meat right there and give it to the customer. (Courtesy of Bert Swanson.)

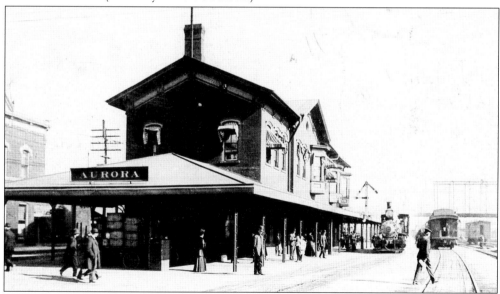

On February 12, 1849, a special charter was granted for the Aurora Branch Railroad. Work began in March 1850 and was complete by 1851. Regular service was inaugurated on October 21, 1850. Secondhand strap rails were purchased from the Buffalo and Niagara Railroad that accepted stock in the road in return. Construction of the road cost $125,868.77. By 1855, the line had grown into the Chicago, Burlington and Quincy Railroad. Pictured is the Aurora depot in April 1911. (Courtesy of Bert Swanson.)

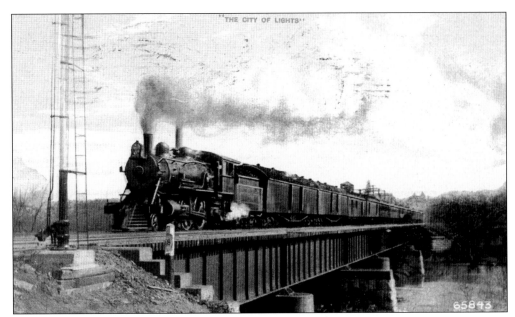

The iron horse of the Chicago, Burlington and Quincy Railroad crosses the Fox River in 1911. The railroad employed 2,400 Aurorans at its peak. Men strong of muscle, long of wind, and steel of backbone worked for $1.50 each day. Thundering through the city constantly were trains on the way west to help build America. The railroad's slogan was "Everywhere West." (Courtesy of Bert Swanson.)

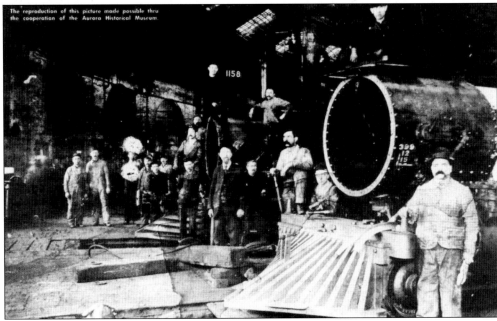

This *c.* 1890 postcard shows the interior of the roundhouse. Aurora's population was 13,000. Industrial prosperity meant 180 businesses, including carriage manufacturers, the Woodworth wagon builders, Aurora Watch Company (1883), the Hoyt Brothers Manufacturing Company, and later the Aurora Corset Company (1895). In 1892, Auroran Frank Hall invented the Braille writer. (Courtesy of Rhea Hunter and the Todd Library/original Aurora Historical Society.)

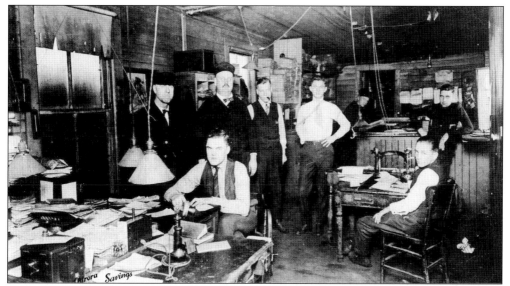

The Chicago, Burlington and Quincy yard office in Aurora is shown here on January 18, 1917. The shops were originally built for repairing equipment but were largely destroyed by fire on Christmas night in 1863. They were rebuilt after the city's acquisition of adjoining land. Trains operated on the surface through Aurora until 1922, when the elevated tracks and new depot were put into operation. (Courtesy of Rhea Hunter and the Todd Library.)

The Van Osuel family poses by their home in this September 1912 postcard. In 1912, Ford was mass-producing the Model T. Production was 82,388 vehicles, and they were sold for $600 each. On October 7, 1913, in Detroit, the first moving assembly line began and heralded the age of mass production and consumption. By 1916, the Highland Park factory was turning out 585,000 vehicles a year at a price of $360. Did this family own a car? Had they just returned from church that Sunday? (Courtesy of Meta Mannion.)

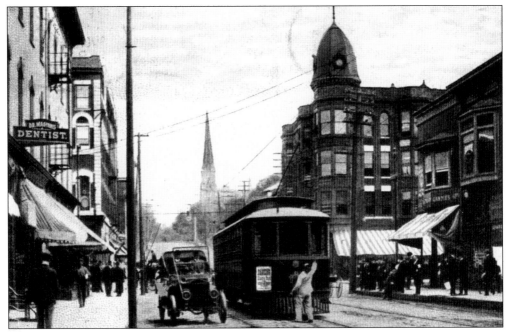

Shown is an August 1910 postcard of Broadway and Fox Streets. The city was growing because of individual effort and commitment. At the New England Congregational Church, the oldest local Boy Scout Troop in continuous existence, troop No. 3, was formed in 1910. Wesley Methodist's Black Hawks formed a troop in 1913, and a troop at Holy Angels church began in 1918. American publisher William D. Boyce and others had formally incorporated the Boy Scouts of America on February 8, 1910. (Courtesy of Meta Mannion.)

Pictured here are Lafey and Selest Scull (née Wallace) of Aurora with children Bill and Arthur around 1912. Lafey was an electric streetcar conductor. They lived on South Lake Street near Lincoln Elementary School. Lafey moved to Tampa, Florida, with his second wife, Gwen "Peggy" Bullock, in the 1940s. (Courtesy of Jeff Scull.)

Three

A FLOURISHING SOCIETY

Yes, Dreams of heat and sun, dreams of tenderness.
Of the scent of roses. And a woman's heart-shaped face.

—Gore Vidal, *Creation: A Novel*

The effect of the railroad on the growth of Aurora was significant. By 1857, the two villages united as the City of Aurora under a special charter granted by the Illinois legislature. The combined population then was about 7,000. The court of common pleas was the city court. It was established by the city charter and given concurrent jurisdiction in the city with the circuit courts of the state in all civil and criminal cases except for treason or murder. In 1865, the legislature amended the city charter and divided the east side into seven wards. The west side portions of the original four wards remained the same. The Aurora Chamber of Commerce in 1937 had 150 industries listed that gave employment to workers and stability to the city's growth.

In 1837, Frederick Stolp had advised his nephew Joseph G. Stolp of the importance of Aurora as a manufacturing location. On January 8, 1842, Frederick laid claim to the entire island of 10 and a fraction acres at a cost of $12.72. When Frederick turned over the island to his nephew Joseph, the young Stolp began cutting timber for a carding mill at the north end of the island. It was 1842 when Joseph procured his patent deed from the government. He "could be seen, any day, ready to sell a lot, or rent a store or office or furnish valuable water power." What once was a meadow soon gave way to Stolp's Island and was then the center of a flourishing city. This was Aurora's first industry other than the saw and gristmills that had met the settlers' needs. In 1849, Joseph G. Stolp built a larger mill that could employ 150 men. The mill was operational until 1887, and Stolp's woolens became famous for their quality. In 1841, Erasmus Woodworth came to Aurora and started a small blacksmith shop. In time, the structure passed into the hands of Keith and Snell, who built wagons for the Civil War. Later it was purchased by W. S. Frazier and converted it into a factory for the manufacture of road carts and racing sulkies. Small industries contributed also to the city's growth, including a distillery operated by John McInhill on the west riverbank that became Aurora Brewing Company.

This remarkable postcard was mailed on July 23, 1909, and signed, "Best Love, Selma." It is reminiscent of the comment that "No other process can render the human face with such fidelity and beauty as photography." Many photographs were immediately made into postcards for mailing to loved ones in those days. (Courtesy of Judy Kenyon.)

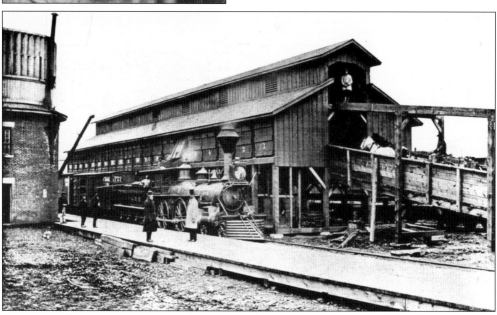

As a railroad center and distributing point for manufactured articles of all kinds, Aurora had no superior. Six trunk and branch lines of the Chicago, Burlington and Quincy Railroad were centered here and reached seven midwestern states. An aggregate of over "7,000 miles of matchless track and equipment" was available to Aurora when the Chicago and Northwestern Railway entered the city. This postcard shows the wood loading of the "tea kettle" and old engine No. 39 around 1866. (Courtesy of Erv and Charlotte Gemmer/Aurora Historical Society.)

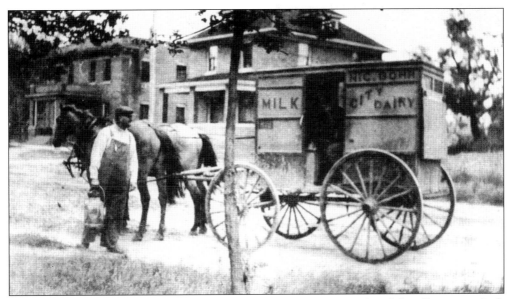

Milk delivery occurred in the early 1900s. Butter "in fair demand and firm," western fresh eggs, and skimmed cheddar cheese were also products that sold well. Eight pounds of Caddy Very Good Tea sold for $2. This scene shows Liberty and Root Streets. (Courtesy of Erv and Charlotte Gemmer.)

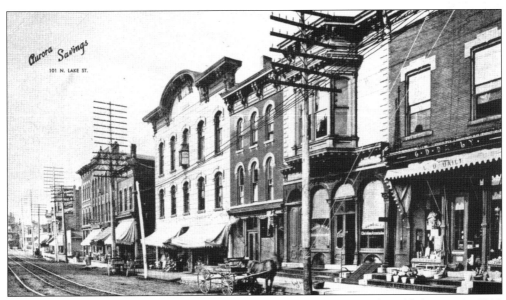

This *c.* 1895 postcard shows Fox (Downer) Street looking west. Retail establishments in 1890 included carriage dealers, gents' furnishings, confectioners, photograph galleries, wool merchants, ice merchants, boarding stables, dressmakers, carpet weavers, feather renovators, an occultist, butchers, bakers, billiard halls, and sellers of books and stationery. (Courtesy of Erv and Charlotte Gemmer/Aurora Historical Society.)

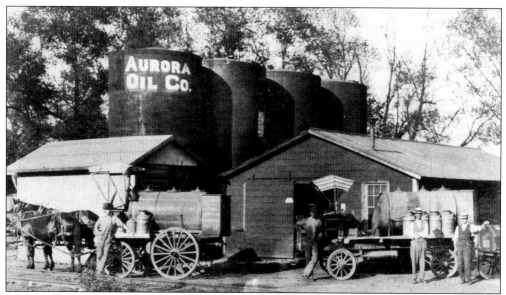

Oil and gasoline were delivered by horse-drawn tanks in the early 1900s. Aurora's deliverymen pictured here were of Irish descent. Immigration from Ireland in 1885 totaled 62,420 in the United States. In the 2000 U.S. census, it was noted that the top ancestries were German with 46.4 million citizens, followed by Irish descent of 33 million. (Courtesy of Erv and Charlotte Gemmer/Aurora Historical Society.)

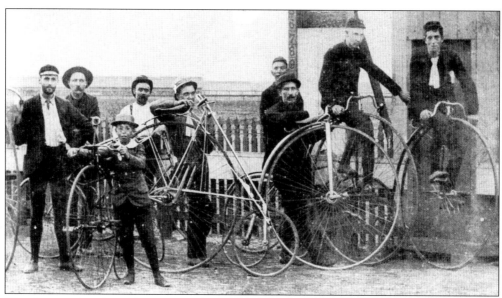

The Aurora Bicycle Club around the 1880s is shown here. Large wheels were practical on muddy or dusty roads. Had the members experienced rain that afternoon? In "April Rain Song," Langston Hughes wrote, "Let the rain kiss you. / Let the rain beat upon your head with silver liquid drops. / Let the rain sing you a lullaby. / . . . The rain plays a little sleep-song on our roof at night / And I love the rain." (Courtesy of Bill Novotny.)

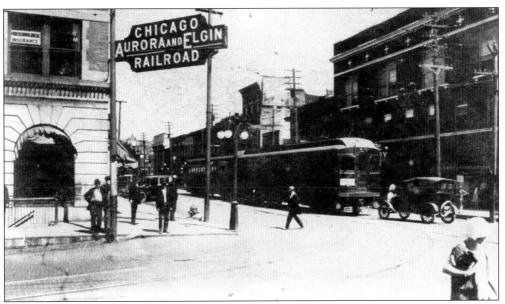

Shown is the Chicago, Aurora and Elgin electric-powered train on Broadway Street at the intersection of Galena Boulevard, at its main terminal. The cars drew power from overhead wires in residential areas and a third rail in the country. The Chicago, Aurora and Elgin Railroad began in 1901. In 1919, the company made improvements, including the purchase of steel cars. In 1949, a round-trip to Chicago cost $1.88. On July 3, 1957, it made its last run. Passengers went to Chicago that morning, but the railroad received approval from the courts to shut down at noon and the service closed at 12:10 p.m. The line continued to carry freight until 1959 but operations ceased in 1961. (Courtesy of Bill Novotny/Aurora Historical Society.)

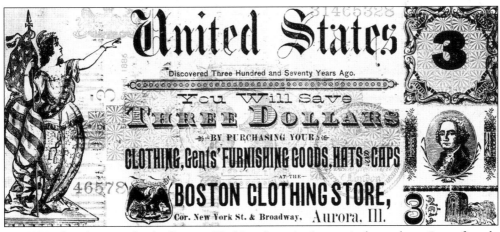

An 1886 advertisement for the Boston Clothing Store in Aurora is shown here. Items for sale included mufflers, collars, cuffs, scarf pins, muslin corset covers, skirts for 45¢, and boys' suits for $1.50. (Courtesy of Bob Arundale.)

In 1838, the first librarian was postmaster Burr Winton. He kept Young Men's Association books in his home. In 1865, the Aurora Library Association's first collection was in the rear of the post office in city hall and it was rent-free. An 1881 ordinance created the Aurora Public Library as a tax-supported institution. The library opened its doors in the Grand Army of the Republic building in 1882. (Courtesy of Joyce Dugan.)

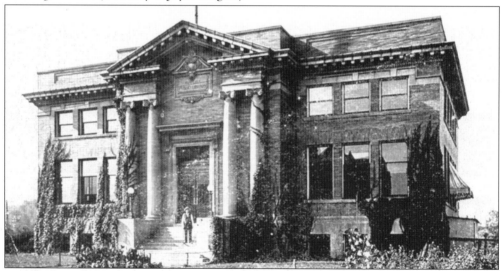

Andrew Carnegie donated $50,000 for the new building in 1900. It was built in 1903–1904, and on August 22, 1904, the building at 1 East Benton Street was dedicated. The building was 15,000 square feet and had 4,000 books. Mrs. Thomas H. Clark was the head librarian from 1881 to 1883. She was followed by James Shaw, Julia Fink, Eleanor Plain, Mary Ormond (née Clark), Janet Plaza (née Pillifant), and, currently, Eva Luckinbill. Since 1999, Luckinbill has developed library services, grown to a holding of 514,000 items, and oversees a $9 million yearly budget. There were 57,000 cardholders in 2006. (Courtesy of Ivan Prall.)

WELCOME TO THE

GOLD CARD CLUB

Books from the library educate and entertain, enlighten and inform. Rudyard Kipling once said, "And on a day that I remember it came to me that reading was a means to everything that would make me happy." In 1999, gold cards were issued for patrons who read 100 books. The Aurora Library was chosen number one in the state for the best public service in 2006. (Courtesy of Diane Christian.)

This moonlit scene along the shore of Fox River Park dates from August 1923. Henry Wolsey Bayfield said it best: "Fire night, an Eclipse of the moon. She rose eclipsed and we missed observing the termination of it by accident." Silent was the night that blanketed this sleeping city of Aurora. (Courtesy of Bob Arundale.)

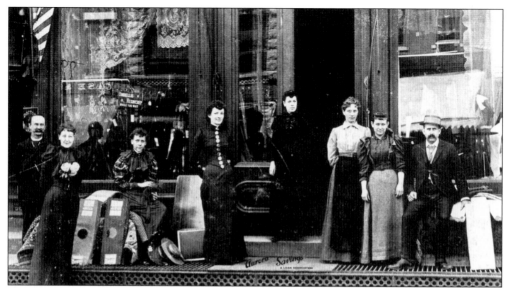

McMillian's Dry Goods, on the northeast corner of River and Downer Streets, is pictured here around 1900. When the workday ended, doors quietly closed and home was the destination. As William Cowper penned, "Now stir the fire, and close the shutters fast. Let fall the curtain, wait on each. So let us welcome peaceful ev'ning in." (Courtesy of John E. Hurt/Aurora Historical Society.)

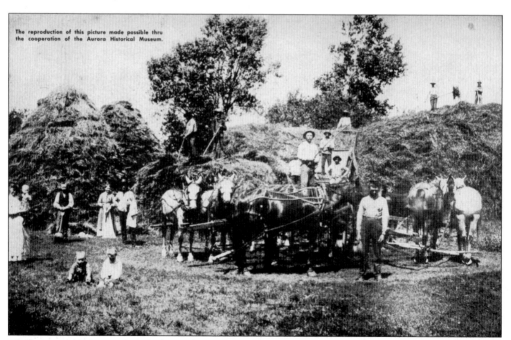

This postcard shows the threshing of grain around the 1890s. Threshers began working in mid-August. Avery steam engines pulled wooden grain separators. The engineer put the rig in the pasture and stoked the fire for the night. Each farmer furnished a jag of coal to fire the engine long enough to thresh his grain. When the steam was up, the horses pulled racks of bundled grain to the separator. Aurora's population on January 1, 1890, was 19,688. (Courtesy of John E. Hurt.)

Clara Westphal (seated) and a friend are pictured here in 1911. Aurora had an ordinance calling for the use of sleigh bells on horses to warn pedestrians of the oncoming vehicle. Few people shoveled their sidewalks, so when the snow was deep, residents walked in the streets. Bricks were heated and wrapped in towels so the passengers could snuggle down in the clean straw, feet touching the hot brick and huge lap robes covering the children. (Courtesy of Carolyn Roesner.)

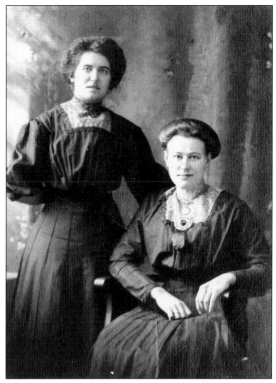

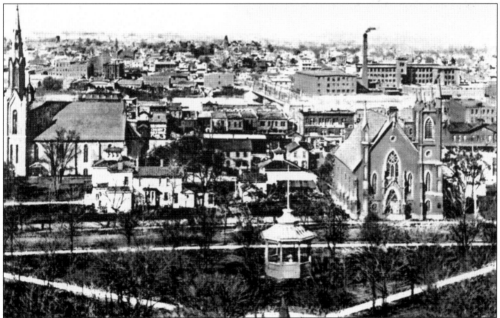

This view looks west from old Center School in 1895. Center School was built in 1866 at the corner of East Galena and Root Streets. There were 10 public school buildings in Aurora in 1890 with "large and commodious rooms and arranged with strict reference to good ventilation, temperature and light." The total cost of operating the schools in 1889 was $80,874.01, including salaries for 72 teachers ranging from $200 to $2,000 each. (Courtesy of Bill Catching.)

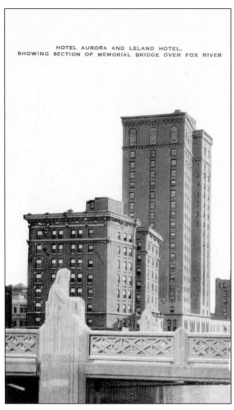

A writer in 1890 wrote of Aurora, "Aurora forms a picture of rare and quiet beauty. A study for the artist and a source of constant delight to the appreciative mind. Given the conditions of running streams, sloping bluffs, fresh breezes from the wide prairies, Aurora can be found as one of the most healthy and progressive cities of the day." This postcard shows the Hotel Aurora and the Leland Hotel. (Courtesy of Bill Catching.)

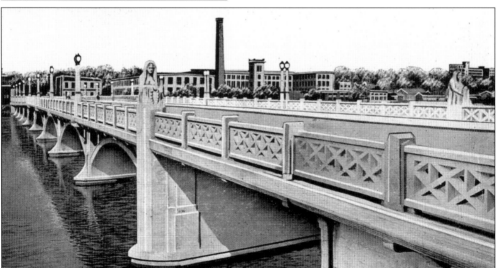

A magnificent system of bridges spans the beautiful Fox River, "giving a variety and picturesqueness to the landscape altogether pleasing." This postcard shows Memorial Bridge, designed by Emery Seidel. In the center of the bridge on both sides are niches with bronze eagles and memorial plaques. It was dedicated on Armistice Day 1931 as a memorial to Aurora's fighting men during World War I. It is one of the most striking bridges conceived with the central figure representing "Victory" and the four illuminated kneeling women representing "Memory." (Courtesy of Bill Catching.)

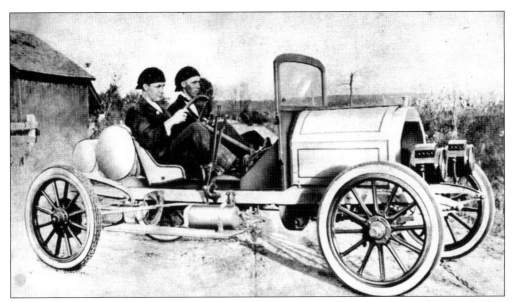

This postcard shows a 1913 Everitt, Metzer and Flanders Company speedster. This was the hot rod of its day. The Everitt, Metzer and Flanders Company was associated with the Studebaker Company. (Courtesy of John E. Hurt.)

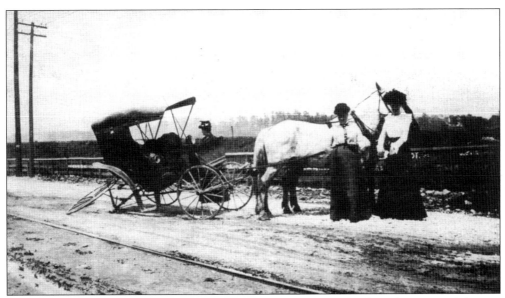

A Sunday afternoon ride in the buggy was not without some difficulty. This postcard shows a family in 1903. Beautiful trees, a clear water spring, and gently rolling pastures created a perfect location for the Riverview Park. A dance hall, bandstand, and refreshment hall were all completed for the opening in 1899. About 1911, the name was changed to Fox River Park to avoid confusion with Chicago's Riverview Park. (Courtesy of John E. Hurt/Aurora Historical Society.)

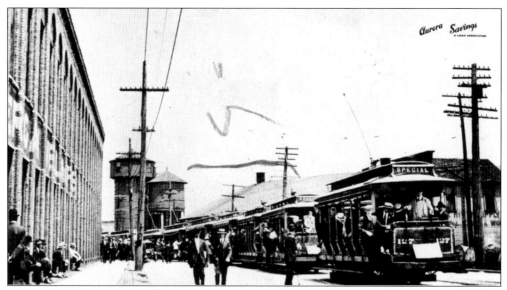

This postcard shows North Broadway Street around 1915. Gentlemen wore suits and ties. The skirts were long for the ladies, and both men and women wore fashionable hats. This was the golden age of postcards as millions printed in Europe were sold and sent in the United States. The new government-printed postcards required 1¢ postage, while privately printed cards required the regular 2¢ letter rate postage. (Courtesy of Rhea Hunter and the Todd Library.)

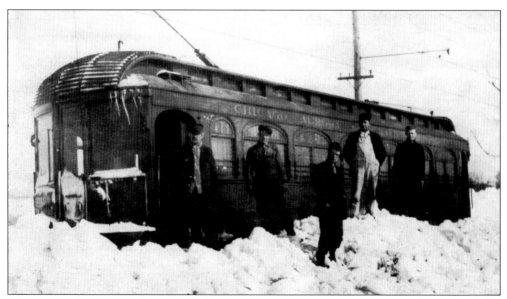

The winter of 1918 not only had a terrible blizzard but also a flu epidemic, which closed Jennings Seminary and saw witness to 300 children at Mooseheart falling ill. Mooseheart had 50 nurses and four physicians attending the sick. Shown on this postcard is an Aurora-DeKalb line streetcar in the snowdrifts. (Courtesy of Erv and Charlotte Gemmer/Aurora Historical Society.)

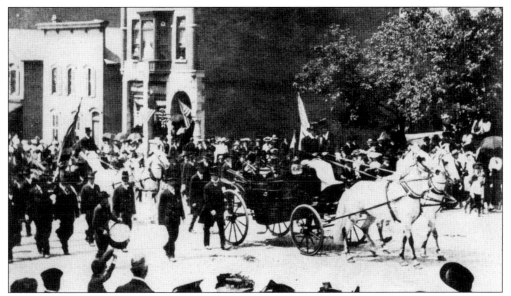

On June 3, 1903, Pres. Theodore Roosevelt enjoyed lunch with Sen. A. J. Hopkins at his home at Lake and Walnut Streets. Albert Hopkins married Emma Stolp in 1873, and they bore four children. During his visit, President Roosevelt spoke to students at Oak Street and Center Schools. He also spoke at Lincoln Park (McCarty Park). Mayor John M. Raymond rode in Roosevelt's carriage that was 1 of 50 in the procession, all pulled by white horses. (Courtesy of Erv Gemmer.)

AURORA
An Architectural Portrait

The historic architecture in Aurora not only beautifies our city, it connects us to the past and provides a unique sense of place that unites us as members of the same community. This can not be achieved in any other media, nor replaced once it is lost.

This brochure depicts many landmarks. Included is the Sencenbaugh home. Charles and Stella Sencenbaugh lived in a Colonial Revival–style home at 1006 West Downer Place in Aurora. He was president of S. S. Sencenbaugh and Western Wheeled Scraper. The high quality goods of the Sencenbaugh department store were reflected in its slogan, "The Store That Sells Quality Merchandise." Its greatest business asset was "absolutely the lasting satisfaction that goes with the knowledge that a fully reliable dealer stands squarely behind their items." (Courtesy of Joyce F. Dugan.)

Never a lip is curved in pain,
That cannot be kissed into smiles again.

This 1912 postcard states a poignant thought. Prior to postcards were the lithograph print, woodcuts, and broadsides. The first postal-type card in the United States was a privately printed card copyrighted in 1861 by J. P. Carlton. This copyright was later transferred to H. L. Lipman. The Lipman Postal Cards were on sale until replaced in 1873 by the U.S. government postcards. The first advertising card appeared in 1872 in Great Britain. The first German card was produced in 1874. A Heligoland card of 1889 is considered the first multicolored card ever printed. (Courtesy of Mary Kies Kramer.)

The railroad companies created standards for railroad grade watches that set new levels of accuracy and resulted in the production of more accurate, standardized timepieces throughout the American watch industry. The term "railroad watch" became synonymous with high quality. (Author's collection.)

Four

TO THE SOUND OF RAIN

With an eye made quiet by the power of harmony,
and the deep power of joy, we see into the life of things.

—William Wordsworth (1770–1850)

Each decade of Aurora's history has had its own distinct pattern. Factors such as economic conditions, modes of transportation, expendable income, and advances in technology have affected the changes. Entertainment in Aurora around 1900 was rapidly changing. Vaudeville's popularity and the advent of motion pictures combined to "make the theatre business boom." Aurora's first vaudeville house was the Bijou Theater. A man named Morris opened the theater around 1900 with a stage that was "roughly constructed of boards and planks" with "camp chairs borrowed from the Al Hobbs Furniture Store." Frank Thielen bought the Bijou with its "small white canvas screen, piano, 200 folding chairs and ticket booth" from Mr. Morris. Thielen then moved the Bijou across the street from 106 Main Street to 111 Main Street and changed the name to the Star Theater. Admission ranged from 10¢ to 50¢ for vaudeville acts and from 5¢ to 10¢ for the silent pictures. Some of the vaudeville acts to appear at the Star included Ross and Elias, the Comedy Barrel Jumpers, the Mysterious Fontinelli, Spellman's Seven Performing Bears, the Marx Brothers, and Paul the Handcuff Mystifier. Thielen enlarged the theater in 1902. He reported losing $100 each week due to slow business and had it not been for his restaurant profits, he would have been forced out of the theater business.

In 1909, an informal reception, grand march, dinner, and dancing was held for the members of the Aurora Odd Fellows and Rebekahs in their armory. Some 300 attended this event. The militants were in full uniform, glittering with gold and resplendent with plumes as they marched with their partners. The spectacle was a brilliant one as reported by the *Beacon*. After the grand march a substantial dinner was served to all in the banquet hall upstairs. Informal dancing continued during the remainder of the evening in the hall that had been beautifully and appropriately decorated with a military theme. Other social news in that edition of the *Beacon* listed Laura Dauberman, who "was an Aurora shopper on Thursday," and reported that J. Harter's family "is now domiciled in its new home west of town." The Odd Fellows' Waubonsie Lodge No. 45 was organized January 3, 1849.

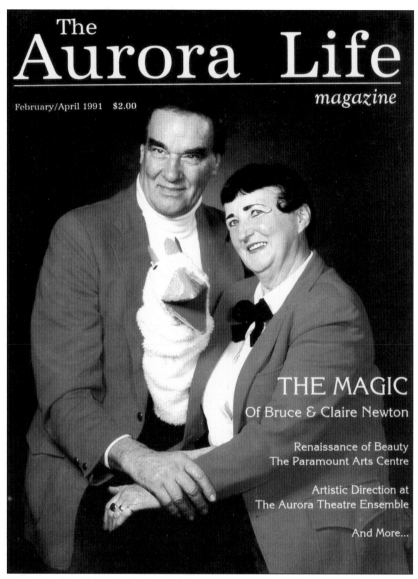

The
Aurora Life
magazine

February/April 1991 $2.00

THE MAGIC
Of Bruce & Claire Newton

Renaissance of Beauty
The Paramount Arts Centre

Artistic Direction at
The Aurora Theatre Ensemble

And More...

After meeting at the Chicago Academy of Fine Arts, Bruce and Claire Newton married on September 23, 1948. They formed a partnership, dynamic and mutually enhancing, that enabled their creative ideas and talents to be born. Garfield Goose was the most famous of the 271 puppets they created. Garfield was a children's television star for 25 years and continues to entertain today. The Newtons raised five children: Sandra, Darry, Kim, Robin, and Tammy. They purchased a rambling 1891 house in Aurora in 1964. Since they had 18 rooms to decorate, they collected antiques. There were 45 potbelly stoves in their home, as well as 85 pairs of curtains, 75 oil lamps, a cider press used as a coffee table, a Thomas Edison cylinder gramophone, a water magnifier, stereopticon, and a black wrought iron hanging light with kerosene lamps. And more—much more. Red, the color, predominates. "I just like red. It cheers you up," said Claire. "It's a vibrant and bright color. We dress alike," said Bruce. Claire died on July 3, 2006. Thomas Baron Macaulay wrote, "Oh, wherefore come ye forth in triumph . . . with your hands and your feet and your rainment all red? And whereforth doth your rout send forth a joyous shout?" (Author's collection.)

PUBLIX **PARAMOUNT** THEATRE

AURORA, ILLINOIS

The Show Place of the Fox River Valley

* * *

INAUGURAL PERFORMANCE

THURSDAY, SEPTEMBER 3rd, 1931

* * *

This Ticket Good Only at the 7 O'CLOCK SHOW on Sept. 3d. Price 50 Cents **Present Ticket at Door and it will be returned to you, as a PARAMOUNT Souvenir.**

In 1930, the Paramount Theater was built on the site where the old Rialto had burned in 1928. It was the first air-conditioned building in Aurora. It was beautifully decorated with eight hand-painted murals. The inaugural performance was held on September 3, 1931, as the major vaudeville movie palace outside of Chicago in the state. The original building cost over $1 million and was designed for talking pictures with vaudeville presented live each Sunday. (Courtesy of Bob Arundale.)

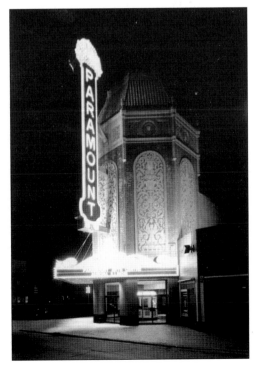

The "Showcase of the Midwest" is located at 23 East Galena Boulevard in Aurora. Ornamental tapestries depicting Venetian vistas line the walls of the lavish art deco theater that has 1,888 seats. It was completely restored in 1978. Current expansion plans will create a theater with a two-story, 10,000-square-foot lobby with elevators, a café, an art gallery, and banquet and convention space. The Paramount Arts Centre was listed on the National Register of Historic Places in 1982. (Author's collection.)

The $1.5 million renovations in 1978 brought Aurora's crown jewel back to its original grandeur. Its art deco beauty was preserved, and according to a *Chicago Tribune* writer, the theater was "Breathtaking . . . Aurora has gambled on the arts to make the Paramount Arts Centre a Midwest Mecca for the performing arts." Performers at the Paramount have included Tony Bennett, Bill Cosby, the Smothers Brothers, Itzhak Perlman, Michael Buble, Neil Sedaka, Glenn Miller, Kenny Rogers, John Houseman, Andy Williams, Carol Lawrence, Jose Greco, Lily Tomlin, and Natalie Cole. (Author's collection.)

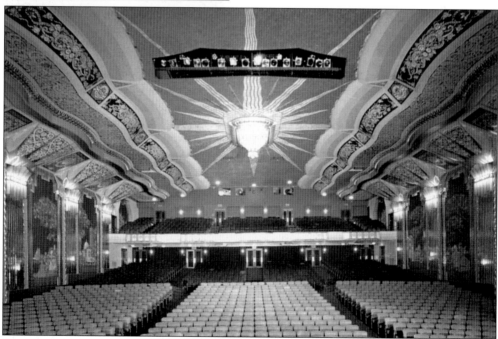

The Paramount Arts Centre serves as the cultural and entertainment center of the Aurora area. Live performances of the highest quality, including classical music, dance, opera, theater, Broadway touring shows, musical events, and children's programming are offered. The variety of entertainment offered reflects the diversity of the Paramount's multistate audience. (Author's collection.)

In 1915, Peter J. Oberweis began selling milk to his neighbors. Since 1927, when Peter bought a half partnership in the Big Woods Dairy, the Oberweis family has been delivering milk. Milk could be safely kept only a few days, necessitating daily home delivery. A quart of milk in 1939, home delivered, cost 15¢. In 1939, Joseph's sister Marie Oberweis joined the family business then located on Lake Street. Marie is shown here (right) with two employees in 1990. (Author's collection.)

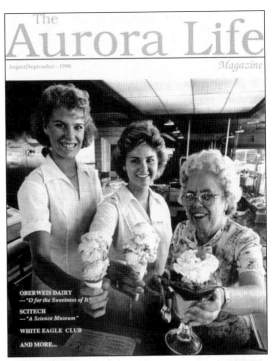

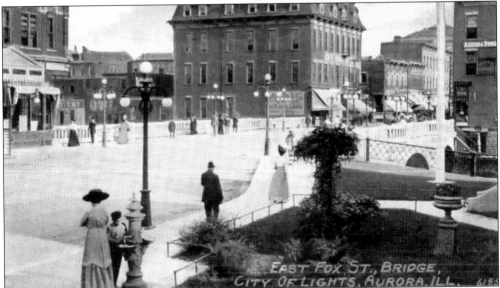

Shown is a busy downtown street. Around the corner was the Grand Opera House. Prominent Auroran and state political figure Col. Henry H. Evans and a group of local investors built the Grand Opera House, also known as the Aurora or Aurora Opera House. Its November 6, 1891, opening went smoothly except that "the stage had been equipped with a gorgeous drop curtain that showed a beautiful sea nymph disporting in the waters. Sad to relate the artist had neglected to provide the lady with clothes. Aurora was shocked. The Chicago artist was sent for hastily. He splashed some foam over the lady where it would do her the most good and all was well." The opera house closed in 1915, a victim of lower-priced vaudeville acts, and moving pictures. (Courtesy of Bob Arundale.)

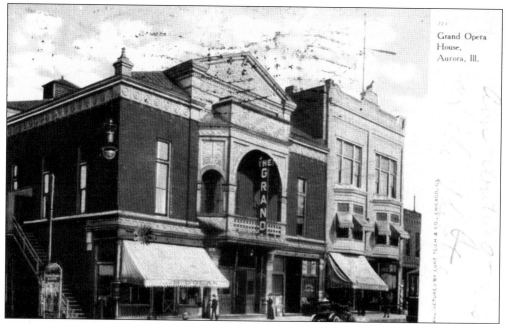

This postcard was mailed on May 22, 1909. The main area of the opera house or parquet, as it was called, had removable seats to accommodate either stage performances or balls. A "grandly curving gallery" held four sections with a total of 54 seats across. Total seating capacity was 900 persons. "Gas lighting and steam heating throughout made the facility thoroughly modern." (Courtesy of Bob Arundale.)

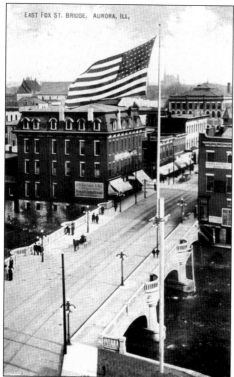

The flags fly proudly over the city as acknowledgment of famous citizen Bernard J. Cigrand (1866–1932), a local teacher. Nationally recognized as the father of Flag Day, he held the first observance on June 14. His 1885 graduating class turned in themes on the American flag. In 1888, he graduated from Northwestern University Dental School. He wed Alice Crispe in 1889 and they raised six children. In 1912, he built a lovely stone house in Batavia. In 1920, he opened his offices in Aurora. Cigrand succumbed to a heart attack on May 16, 1932. This postcard was mailed on October 13, 1911. (Courtesy of Bob Arundale.)

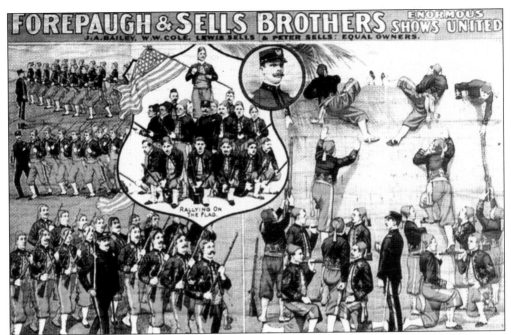

The world champion Aurora Zouaves are shown in 1891 on Hurd's Island. This world-famous drill team performed military close-order precision drilling. The members stepped in perfect unison as they performed intricate maneuvers, tight order drills, and wall-scaling feats. The team was organized in August 1887 with G. A. Hurd as captain. This postcard was produced by the Aurora Historical Society in 1988. (Courtesy of Bill Novotny/Aurora Historical Society.)

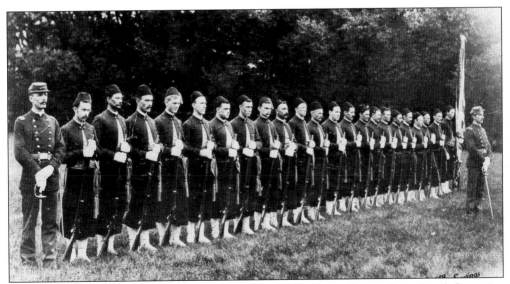

In 1891, the Aurora Zouaves entered an interstate drill held at Indianapolis and took first prize of $1,000. After Hurd's retirement in 1892, Albert Tarble led the group in Savannah, Georgia, in May 1896. The team again took first honors, first prize, and the world champion title. They performed extensively in Europe in 1901–1902. The team disbanded during World War I but reorganized in 1936–1937 to celebrate Aurora's centennial. (Courtesy of Tom Deisher/Aurora Historical Society.)

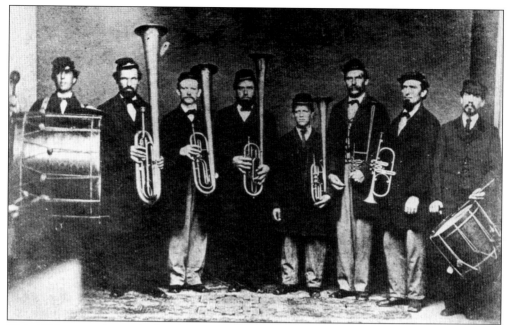

This 1850s scene shows the local band playing at the foundation laying of Clark's (Jennings) Seminary. (Courtesy of Erv and Charlotte Gemmer/Aurora Historical Society.)

From left to right, this postcard shows three Aurora friends, Inez Bowman, Charlotte Dienst, and Carolyn Hunt, around 1910. It must have been a lovely spring day. "Friendship needs no words. It is solitude delivered from the anguish of loneliness," wrote Dag Hammarskjold. (Courtesy of Carolyn Roesner.)

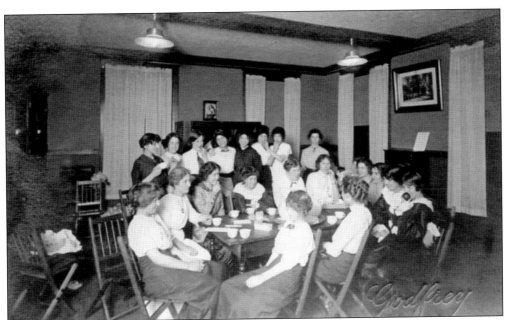

Entertainment could be centered around the home in the 1920s. This postcard by Godfrey of Aurora is simply titled *Girlfriends*. (Courtesy of Carolyn Roesner.)

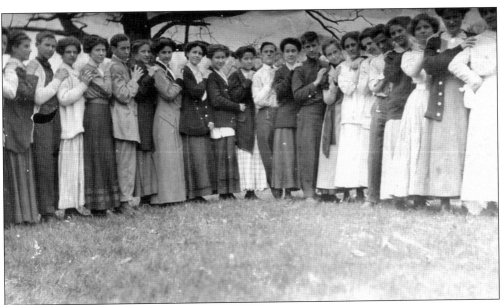

This 1911 postcard of a group of East High seniors includes Charlotte Dienst. Charlotte Dienst, a great aunt of Carolyn Roesner, was born in 1893 in Tokyo, Japan, where her father, Dr. George E. Dienst, was teaching and doing missionary work. In 1898, the family of six children and wife Clara returned to America. They moved to a home in Aurora at 438 Maple Avenue in 1908. George started a medical practice in Aurora that he maintained until his death in 1932. Charlotte never married and devoted her life to music and assisting her sister Robbie, who owned Robin's Bookshop in Geneva. (Courtesy of Carolyn Roesner.)

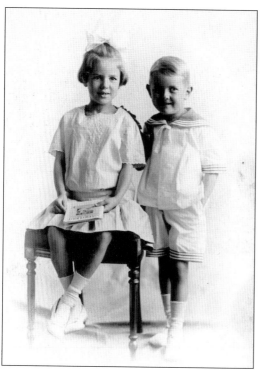

Brother Myron Kendall, age five, is pictured here around 1915 with his sister Lue, who was six years old. The postcard was mailed from Boston with greetings to an Aurora address. (Courtesy of the Aurora Historical Society.)

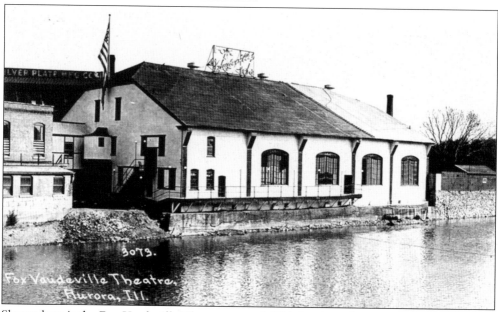

Shown here is the Fox Vaudeville Theatre around 1911. In 1910, the Fox was converted from the Coliseum, and a variety of local sources indicate that it had been originally constructed at the Temple of Music Building at the Pan-American Exposition held in Buffalo, New York, in 1901. That was the structure in which Pres. William McKinley was assassinated that same year. Note the roof sign that reads "Vaudeville" for 10¢. The building was used for "public roller skating, prize fights, prime social events and public banquets." The Fox Theater was condemned in June 1930 and razed in October of that year. (Courtesy of Bert Swanson.)

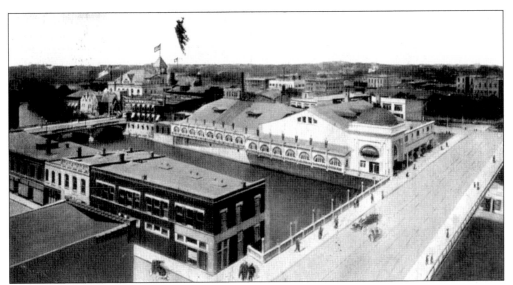

Jules Rubens and Frank Thielen opened the Sylvandell Dance Hall in 1915, directly north of the Fox Theater. In 1919, the dance hall became a motion picture and symphony hall. The Fox Promenade included a new "supervised lounging department, new restrooms, check rooms and a nursery room where children could be left in the charge of competent nurses." A pipe organ was installed at a cost of $15,000. For the next decade, Sylvandell was the center of entertainment in Aurora. (Courtesy of Bert Swanson.)

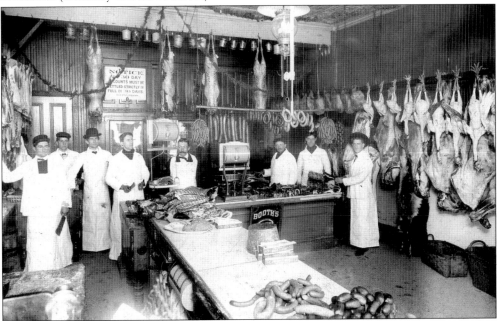

August Hipp supplied the many downtown restaurants and theater patrons with delicious meats. His market was located at 87 LaSalle Street. August is fourth from the left in this scene, and his father, Martin, is fifth from the left. Grandpa August Hipp had paid $1,300 for the building in 1907. An advertisement in the *Aurora Beacon* suggested that "you send your husband for meat" at Hipp Meat Market. "We keep choice meats only" so he "cannot go very far wrong in his selection of meat for the table." (Courtesy of Tom Deisher.)

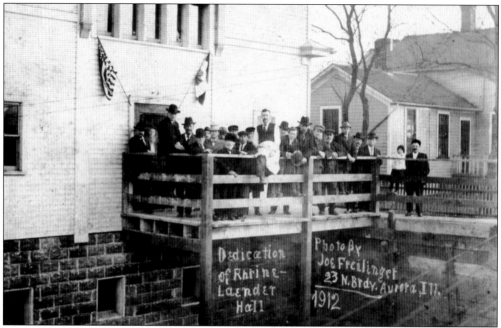

Shown is the dedication of the Rhrine-Laender Hall in 1912. The Fox River is either the backdrop for so many activities in Aurora or else within walking distance. The striking natural resource that is the Fox River originates about 15 miles northwest of Milwaukee and is a 185-mile-long waterway. Agnes DeCourci wrote, "she invited us to take our tea in a small summer room, on the brink of a delightful river." (Courtesy of Bob Arundale.)

Since postcards were hand stamped in 1924, a tired worker must have forgotten to put the Illinois stamp in the right direction, hence the backward postmark of "LLI." (Courtesy of Bob Arundale.)

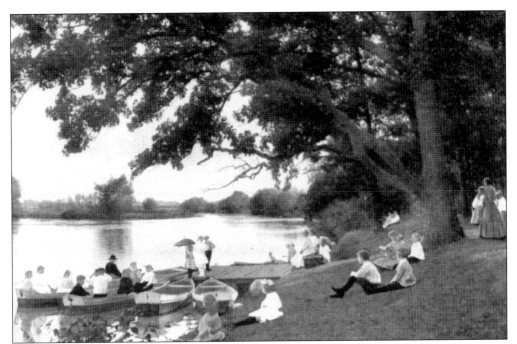

This tranquil scene took place around 1905 at the Fox River. By 2004, the Fox Valley Park District maintained 135 parks and 33 miles of trails. The area encompasses 57 miles of land as well as 22 miles of shoreline along with Fox River. There are 78 playgrounds, 29 outdoor tennis courts, and nine indoor tennis courts. "Our goal is to have a park in every neighborhood," said Amy Larson of the Fox Valley Park District. (Courtesy of Bert Swanson.)

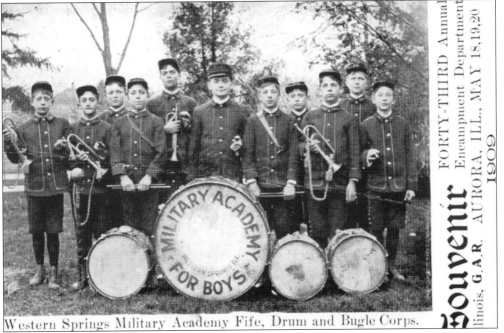

Western Springs Military Academy Fife, Drum and Bugle Corps.

This postcard shows the Western Springs Military Academy Fife, Drum and Bugle Corps during the 43rd annual encampment in Aurora on May 18–20, 1909. (Courtesy of Bob Arundale.)

Wishes on this postcard state, "A Happy New Year 1912." The year 1912 had been witness to the *Titanic* disaster, the entrance of New Mexico as the 47th state, and airmail service inaugurated between Paris and London. The dance turkey trot debuted in London and the *London Times* reported that ". . . these dances are sensual in their aim." Sophie Tucker had a hit song with "Some of These Days," and the Peerless Quartet sang "Let Me Call You Sweetheart" on the Columbia label. Popular phrases in 1912 included "It's a cinch," and "It's just peachy." (Courtesy of Myron Nelson.)

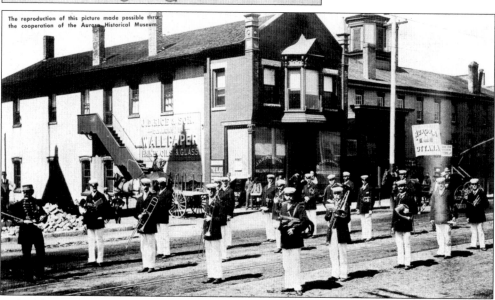

Walter Egerman leads the Aurora Military Band on Fox Street in 1892. (Courtesy of Abbie DeSotell/Aurora Historical Society.)

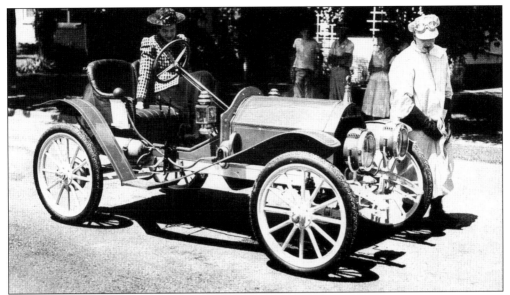

Shown is the 1908 Hupmobile Runabout. This car was a 20-horsepower model and cost $750 FOB (Frieght on Board) Detroit. Equipment included three oil lamps, tools, and a horn. Costing extra were the top, gas lamps, tank or generator, speedometer, and trunk rack. This popular car was made from 1907 to 1932. The finely dressed couple might have been going to a downtown theater that breezy afternoon. (Courtesy of Abbie DeSotell.)

Many merchants used trade cards for advertisements. These two cards for Clark's cotton thread reflect the variety of those cards. Du Pont would announce a name for its new synthetic yarn in 1938: nylon. Thread made of nylon became popular with the many seamstresses in Aurora. (Courtesy of Bob Arundale.)

The Fox Valley Symphony was a professional orchestra of 70 musicians. It began as a chamber orchestra in 1957 and grew to include annual youth concerts, a five-concert subscription series that included pops, family, and classical concerts, and a Young Performers Competition each season. Gibby Monokoski of Waubonsee Community College was president of the symphony during its 1996–1997 season. The symphony ceased performing in 2001 as a result of declining subscriptions following 9/11. (Author's collection.)

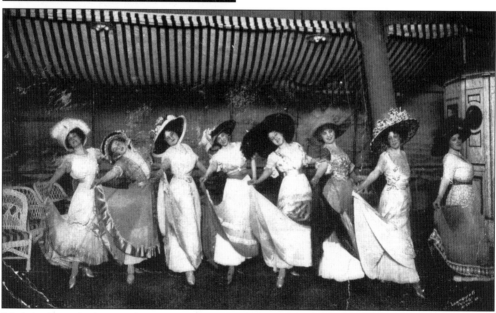

Madame Sherry had opened at Broadway's New Amsterdam Theatre on August 30, 1910, and ran 231 performances. It was a successful show and was revived by regional and amateur companies up until the early 1950s. Music was by Karl Hoschna and lyrics and book by Otto Hauerbach. This performing group, like many to follow, could work magic with "the instruments of their choosing—trumpets, cellos, cameras, paintbrushes, or imagination." (Courtesy of the Aurora Historical Society.)

This 1908 postcard features a beautiful young woman advertising the Akron Mining, Milling and Manufacturing Company. "We are makers of custom paint and manufacture goods to fit individual requirements. An opportunity to figure on your paint needs will be a pleasure to us and, we think, profitable to you," reads the back of the card. (Courtesy of the Aurora Historical Society.)

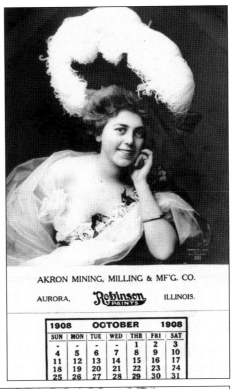

AKRON MINING, MILLING & MF'G. CO.

AURORA, *Robinson* PAINTS ILLINOIS.

1908		OCTOBER			1908	
SUN	MON	TUE	WED	THR	FRI	SAT
-	-	-	-	1	2	3
4	5	6	7	8	9	10
11	12	13	14	15	16	17
18	19	20	21	22	23	24
25	26	27	28	29	30	31

Thomas Thayer mailed this postcard to his aunt Mary Kies on February 6, 1914. On June 26, 1913, the General Assembly of Illinois granted women the right to vote in presidential elections, making Illinois the first state east of the Mississippi River to do so. In 1916, Kies could have voted for Republican Charles E. Hughes or for sitting president Woodrow Wilson, a Democrat and the eventual winner. The 19th Amendment was officially adopted on August 26, 1920. (Courtesy of Mary Kies Kenyon.)

Cousin Lizzie Kies mailed this card to Mary Kies on December 14, 1907. She inquires about the weather in Aurora and comments that "It is rather gloomy here." The salutation is "As ever your cousin," Lizzie Kies. Sir Henry Cole, the Englishman who drew the sketch for the world's first postage stamp, the Penny Black, conceived the idea for the first Christmas card in 1843. That card depicted a family toasting the season with wine. About 1,000 cards were sold that first year. (Courtesy of Mary Kies Kenyon.)

Erected in 1855, the Aurora roundhouse was the oldest full roundhouse in the country and the only stone roundhouse remaining in the United States, seen here in this award-winning photograph. The National Park Service has deemed the complex "of preeminent importance in American transportation history," and it is listed on the National Register of Historic Places. The Chicago, Burlington and Quincy repair facility closed in 1974 and a portion was demolished in 1977. City officials then formulated plans to create an intermodal transportation complex. (Author's collection.)

Five

HARMONY AND
HONEYCOMBS

*The shadowy forms of men and horses, looming, large-sized, flickering, and over all,
the sky—the sky! Far, far out of reach, Studded, breaking out, the eternal stars.*

—Walt Whitman (1819–1892)

The harmony of life in Aurora in the 1850s was a mosaic bordered by family, church, school, and work. In 1856, an average home could be built for $1,000 complete, while a four-story brick store downtown could be built for $10,000 including the land. In both Dunning Hall and the Main Street Concert Hall were many brilliant social events, balls, and theatricals. Aurora, the beautiful city, was experiencing both growth and prosperity. Its factories and mills were humming with activity.

A Methodist Episcopal minister named John Clark first conceived Clark Seminary, later Jennings Seminary, about 1850. A charter was granted in 1855, and by 1856, the building was started and the school opened in 1858. It was housed in a stone structure on South Broadway Street where Jennings Terrace stands today. The first parochial school was St. Paul's Lutheran, which began in 1854–1855. There, George Grass taught a few children in a small building on the northwest corner of River and Walnut Streets. St. Nicholas School was the first Catholic school in Aurora. A frame church had been built at High and Liberty Streets in 1862. Rev. J. Westkamp was the first resident pastor, and he soon opened a school with the church organist as teacher. By 1875, there were 17 congregations addressing Aurora's spiritual needs.

Samuel McCarty prompted the organization of the First Methodist Episcopal Church at a meeting in his home in 1837. Among the oldest of the city's congregations are the First Congregational, which was organized in 1838 as a Presbyterian church, the Universalist in 1842, First Baptist in 1844, Trinity Episcopal in 1849, St. Mary's Catholic in 1850, and St. Paul's Lutheran Church in 1854.

New England Congregational Church was organized on July 1, 1858, by 17 members of the First Congregational Church who were granted letters of withdrawal. They first met in the Methodist church, later in a room over the Phillips' store on River Street, and in 1859 erected their first church on Locust Street where Holy Angels School now stands. Their first pastor, Rev. G. B. Hubbard, stayed for seven years for a salary of $600 a year. In 1890, the present structure at Chestnut Street and Galena Street was built at a cost of $25,000.

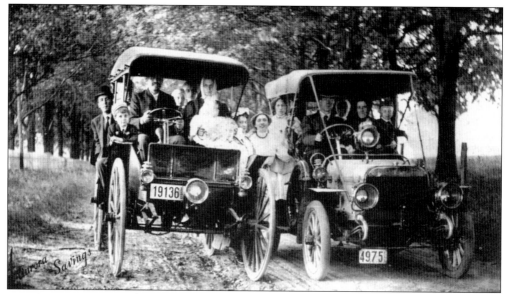

Shown are a 1909 International (left) and a 1909 Winton with Philip Rudolf at the wheel. The families may have enjoyed a Sunday drive following services at the Wesley Methodist Church, 14 North May Street, which opened in 1858. Today the ministry team is headed by senior pastor Tracy S. Malone. The chancel choir and sanctuary bell ringers participate in the weekly worship service. (Courtesy of Abbie DeSotell.)

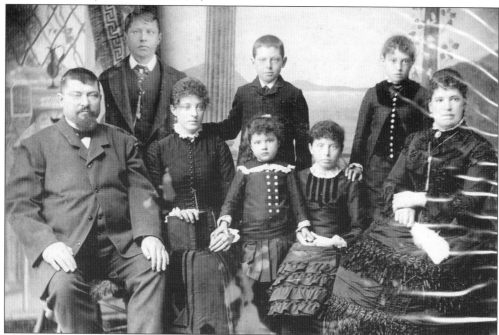

The Frank Unfried family is shown here in 1886. They lived at the corner of Hill and Fifth Avenues in Aurora. Frank left Germany in 1841. He owned a meat market on Main Street for 40 years. Pictured from left to right are Frank, Frank Jr., Kitty, Theodore, Cora, Anne, Lillian, and Aunt Lizzie. The postcard suggests closeness between them, the eternal bond unmistakable. (Courtesy of Bill Novotny.)

A Richards-Wilcox Manufacturing Company 1918 calendar is shown on this postcard. The father of Marian Richards Furnas (1898–1992) and her uncle began the firm in their basement. "My father was the dreamer," Marian said, "and my uncle had the business sense. They began work in our basement." Marian and Lee Furnas lived at 202 South Gladstone when they met Jo Fredell Higgins in 1971, and then they moved to 202 South Westlawn on Aurora's west side. (Courtesy of Bob Arundale.)

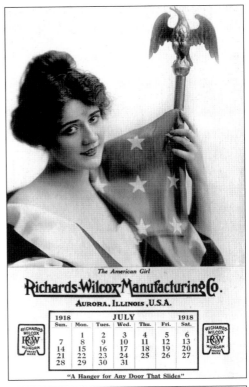

The First Presbyterian Church dates from June 13, 1858. In 1861–1862, a frame building on Galena Street was erected and used until 1872, when it was sold. The present location was purchased and a new frame church dedicated on February 1, 1874. The current church was constructed in 1902 in the Romanesque Revival style. The original building stood until 1916 when the congregation enlarged its building. This postcard is from around 1908. (Courtesy of Myron Nelson.)

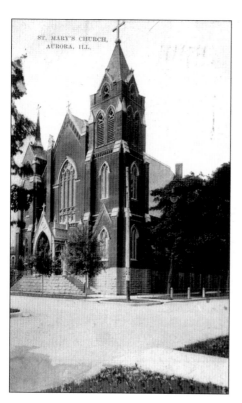

St. Mary's Catholic Church dates from 1850. Bishop Vanderveld bought 19 acres on Broadway Street and built a small frame church in 1851. It was blown down by a heavy gale. A stone church was built at the corner of Pine (Grand) Avenue and Spruce Street, but burned down in 1869. A new building was constructed in the Gothic Revival style at the corner of Fox and Root Streets in 1871–1872. More than 100 volunteers dug the trenches for the foundation in less than three hours. The original congregation was mainly comprised of Irish immigrants. (Courtesy of Martha Ingraham.)

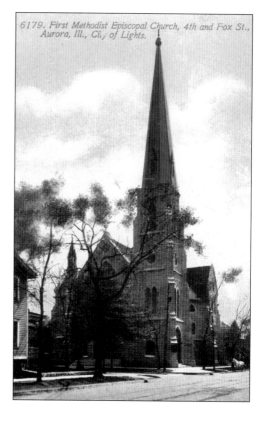

First Methodist Episcopal Church at Fourth Street and Fox Street (Downer Place) was organized in September 1837 in the log cabin of Samuel and Phoebe McCarty. Building began in 1843 on the site of the present edifice at Fox Street and Lincoln Avenue. The structure seats 1,000 and was completed in 1872. It was dedicated on December 27, 1874, at a total cost of $60,000. In 1951, the original steeple was weakened by winds and removed. (Courtesy of Roy Randall.)

Our Savior Lutheran Church at 420 West Downer Place is a beautiful edifice that was organized in June 1935 with the building cornerstone laid on Memorial Day 1939. In 1943, the congregation was 700 souls, with 411 communicants exclusive of the 36 men in the armed forces, and had 67 voting members. (Courtesy of Erv and Charlotte Gemmer.)

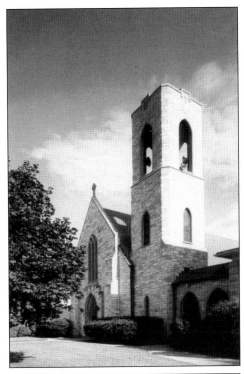

St. Nicholas Parsonage in Aurora is shown on this postcard. German-speaking families wanted a church where their native tongue was spoken and organized the church in 1861. The church was built at High and Liberty Streets in 1882–1887. The congregation began an extensive building program in 1953–1954, including a new school. A designated local landmark, this Gothic Revival church was constructed of brick with limestone detailing. Today the parishioners are almost all Hispanic. (Courtesy of Bob Arundale.)

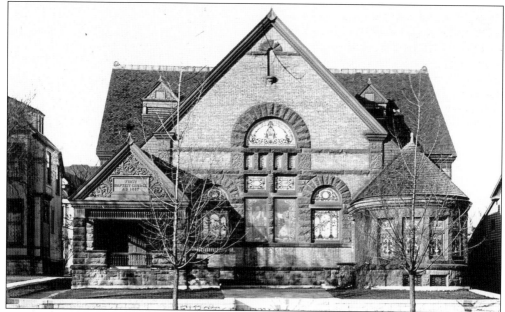

The First Baptist Church dates from 1837. Services were held in private homes in the Big Woods area. In 1847, the organization moved to Aurora. It purchased a large house on Galena Street hill and in 1886 moved the house to the back of its lot and built a Romanesque-style church designed by the Chicago architectural firm of Edbrooke and Burnham. The church was dedicated on May 6, 1888, at a cost of $20,000. It was fully subscribed, so the congregation moved into a debt-free church. (Courtesy of Bob Arundale.)

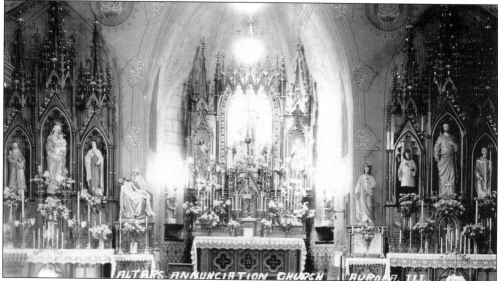

The Annunciation Catholic Church altar is depicted in this postcard that was mailed in 1937. A constitution for the church was drawn up in March 1875. Annunciation was built in the Gothic Revival style using native limestone in 1875. It was completed in 1877 at a cost of $16,000. Luxembourg immigrants were early members of the church. The first resident pastor was Rev. John B. Kanzleiter. The parish is graced with a Grotto of Lourdes of the Blessed Virgin. (Courtesy of Bob Arundale.)

St. Paul's Evangelical Lutheran Church began in 1854. In 1872, men with high-topped silk hats and Prince Alberts and women with wide flowing skirts and pretty shaped bonnets attended services. St. Paul's currently holds an English as a Second Language (ESL) program with over 100 participants. The pastors are Jock Ficken, Alex Merlo, and Tom Sayre. (Courtesy of Bob Arundale.)

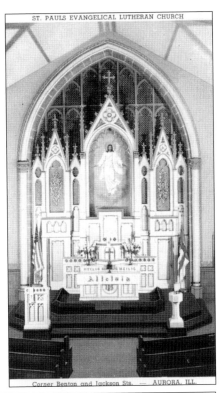

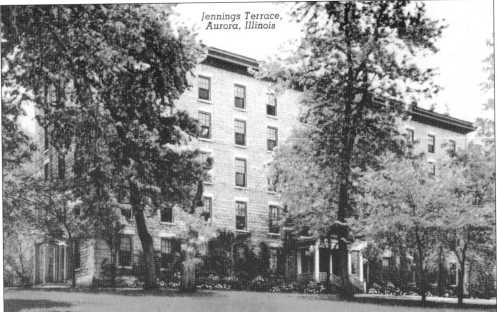

Early in the 1820s, the Rev. John Clark determined that a Christian high school should be established in the Fox Valley area. In 1855, the charter was procured, and in 1856, $25,000 required by the charter had been subscribed. Corwin and Company won the contract to lay the foundation for $4,220. In 1858, Jemima Washburn was assisted by three other teachers for the 40 enrolled pupils. Shown is Jennings Terrace in Aurora. (Courtesy of Bob Arundale.)

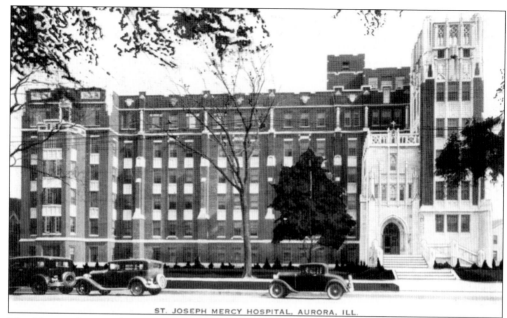

ST. JOSEPH MERCY HOSPITAL, AURORA, ILL.

The Sisters of Mercy founded St. Joseph Mercy Hospital. In 1911, a 30-bed health service began in a red brick apartment building located on the corner of Lake and West Park Streets. In 1931, a spacious new hospital opened next door and was used until 1971 when the new facility at Mercyville was opened. There are five medical buildings now on a 160-acre wooded campus on Aurora's west side. In 1988, with a staff of 260 physicians, there were 7,583 surgeries performed and 1,038 births. (Courtesy of Bob Arundale.)

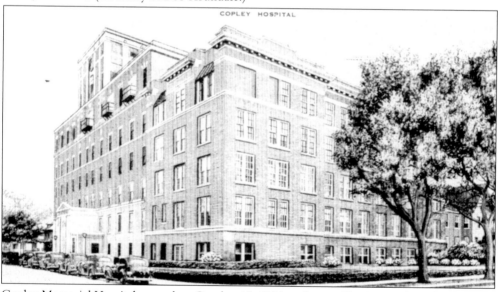

COPLEY HOSPITAL

Copley Memorial Hospital opened on October 12, 1886, as Aurora City Hospital. Hattie Hollister Vaughn was the matron in charge of two nurses and a kitchen maid. In 1888, construction began on the Lincoln Avenue hospital. In 1912, a sum of $100,000 was raised for a modern five-story structure. The medical staff in 1916 comprised five doctors. On November 18, 1995, opening ceremonies were held as the hospital had relocated and had become the Rush-Copley Health Complex on Route 34 in Aurora. (Courtesy of Bob Arundale.)

St. David's Episcopal Church celebrated its 50th anniversary in February 2006. The first service was held on March 4, 1956, in the Lowry Chapel of Aurora College. The present edifice was built in 1959 at a cost of $148,000. The architect designed it in the English country style. The limestone for the cornerstone came from the same quarry in Wales where the original St. David founded the first Welsh church in the sixth century. (Courtesy of Pastor Sue Holstrom, rector.)

The YWCA was organized in 1893 in two second-floor rooms on the northeast corner of Downer and Island Avenue. Sunday vespers, Bible study, and recreation were the first activities. After raising $60,000, a new YWCA was dedicated. The YWCA acquired Quarryledge in 1926 as a campsite for young ladies. In 1962, the YWCA had 6,548 active members. Since 1975, a yearly Women of Distinction award luncheon has been held to honor and recognize local women of accomplishment. A new YWCA opened in 1985 on seven acres adjacent to the Fox River. (Author's collection.)

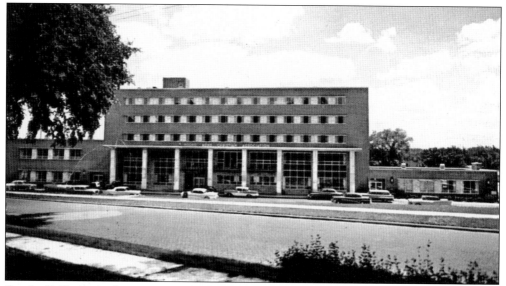

On April 29, 1869, the groundwork was laid for the YMCA of Aurora. The men wanted to establish a Christian reading room "to guard the young men from the evil influences that surround them." It was the first YMCA in Illinois to build its own home and the fifth worldwide. In 1888, a new gymnasium was added. Ground was again broken in October 1907. In 1954, on land donated by Col. Ira C. Copley, new construction began. It was completed on May 18, 1958. Leadership brought about the consolidation of the Aurora and Naperville YMCAs with ceremonies on January 8, 2000. (Courtesy of Bob Arundale.)

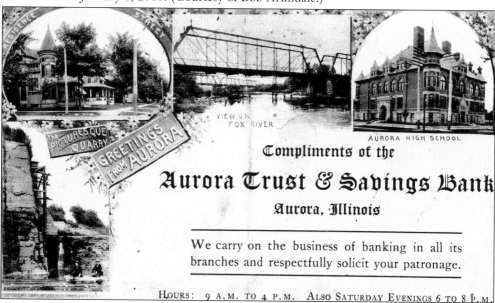

Phillip, Benjamin, and Myron Hall established Aurora's first exchange bank in 1847. The three brothers set up an exchange counter in their mercantile store on River Street. They later established the Bank of Aurora with a capital of $330,000 and issued their bills, as was the custom then, largely based on Missouri bonds. In 1855, they erected a bank building on the north half of where the Old Second National Bank (established in 1871) now stands. An Aurora Trust and Savings Bank postcard from around 1903 is shown here. (Courtesy of Bob Arundale.)

John Cheever wrote, "A railroad station is a human symbol, striking architectural poetry about our passages together. Proportioned like a cathedral and lit by a rose window . . . it is a gloomy and brilliant example that means to express the mystery of travel and separation." This *c.* 1916 postcard shows the Aurora, Elgin and Chicago Railroad terminal station. (Courtesy of Roy Randall.)

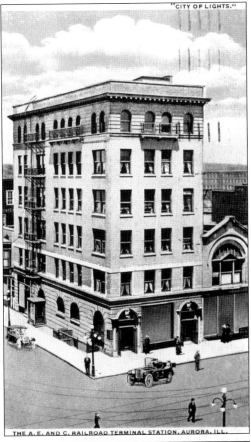

THE A. E. AND C. RAILROAD TERMINAL STATION, AURORA, ILL.

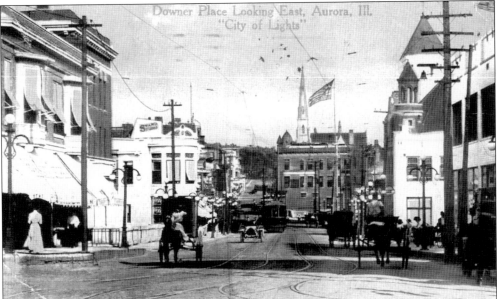

This view shows Downer Place around 1916 looking east. One can see the saucy tilt of the straw hats as the gentlemen make their way home with their packages. (Courtesy of Bob Arundale.)

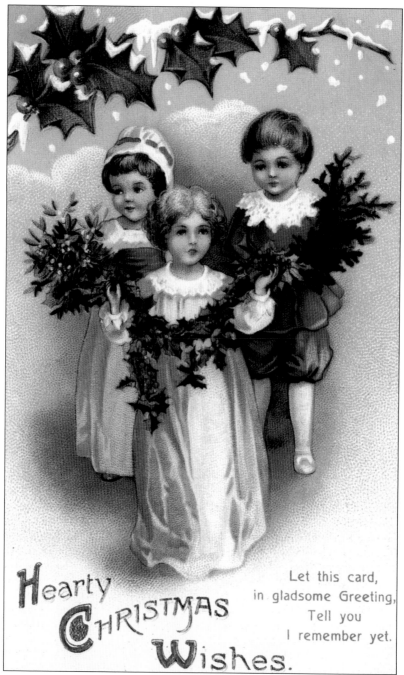

Hearty CHRISTMAS Wishes.

Let this card, in gladsome Greeting, Tell you I remember yet.

Shown is a 1912 postcard depicting three charming children with hearty Christmas wishes. Christmas Eve was cold that December and every flatiron in the house was heated and wrapped in a towel. "The irons warmed the beds sufficiently until one was nestled down in those deep feather beds. Sister had brought in several pounds of fresh farm butter in exchange for a crate of oranges from the general store. We listened to Christmas music on the graphophone. Kerosene lamps and candles were lit. Mother was popping corn and the hot cider tasted especially 'peachy' on this most solemn night." (Courtesy of Mary Kies Kenyon.)

Six

BREAKFAST, A PETIT DEJEUNE

One eats in holiness and the table becomes an altar.

—Martin Buber (1878–1965)

Aurora families in the 19th century were large and patriarchal. They encouraged hard work, respectability, social deference, and religious conformity. The Victorian era (1837–1901) was characterized by developments in nearly every sphere. Etiquette for both ladies and gentlemen was well defined. A lady was to be quiet in manner, natural in her language, and with a pure mind. A gentleman was to be refined, tender and gentle, and prudent and patient. Both were to dress well, exhibit fine table manners, and be disciplined in their intellect. During this era, there were rapid transformations that began the age with confidence and optimism and produced economic boom and prosperity. The railway network stimulated travel and leisure opportunities.

A West Aurora Alumni Association annual meeting and banquet was held on June 16, 1903, at the Aurora City Club at 8:00 p.m. Lillian Pike Harkison was the toastmistress. Denney's Orchestra played for the dancing after the banquet. A lively debate at Aurora College on June 9, 1903, was won by the affirmative of the question "Resolved, That Woman is Equal to Man in Mental Capacity." The Webster Society won over the Lincoln Society. The debate was well attended, and the audience was closely interested and frequently applauded. From the winning side "came a voice, clearer than the notes of the sweetest songsters in all the surrounding forests" and "lo, it was even so that Woman must have excelled man in debating that day."

The clerks of the Wilcox Dry Goods and Millinery were pleasantly entertained at the home of Carrie Phillips in June 1903. The hostess was presented with a beautiful silk umbrella on behalf of the guests. A bounteous dinner was served at five o'clock after which the guests returned to their homes. And a *Beacon* article of June 11, 1903, headlined "Matchless Magnificence of a Free Street Pageant." Adam Forepaugh and Sells Brothers' Enormous Show was the "most gorgeous spectacle ever beheld" and was constructed especially with cages, tableaux, chariots, and all sorts of mammoth vehicles. More than 400 of the finest draught horses in America "will be seen as well as four herds of elephants, 100 thoroughbred horses of high degree and a wealth of magnificence and splendor." The parade moved from the show grounds at "about nine o'clock passing through the principal streets of the city." The weather remained generally fair with fresh northwest winds for this event.

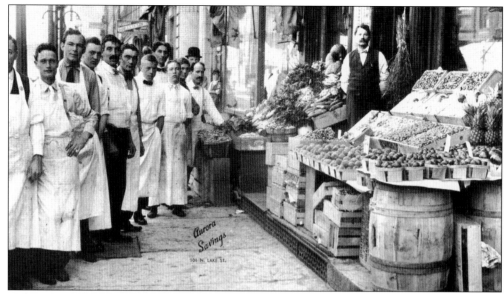

This is a delightful postcard of Marshall's Grocery Store at 32 South River Street around 1890. Herbert Titus opened the store at the corner of River Street and Downer Place in 1863. Clarence W. Marshall later became a partner. In 1913, the bakery, kitchen, and meat departments were added at the larger quarters at 46–50 Downer Place. In 1890, mincemeat was 5¢ a pound and new sauerkraut was 7¢ a quart. Marshall's expanded after 1915 to a chain of cash stores that "received a very satisfying response from the public." (Courtesy of Bill Novotny/Aurora Historical Society.)

The stone for many buildings and sidewalks in Aurora came from the South Broadway quarry. The Chicago, Burlington and Quincy depot and Railway Express building were built on the filled quarry. By 1900, Aurora was an important hub for railroad transit during that halcyon time. (Courtesy of Abbie DeSotell.)

R. C. Allen's grocery store was located at 14 South Broadway Street, just south of Main Street on the east side. The 1850 city directory listed it, indicating that it "sold fancy groceries." Breakfast items included boiled hams that sold for 10¢ a pound, fancy German salami for 8¢ a pound, homemade country sausage for 6¢ a pound, and lamb chops for 9¢ a pound. (Courtesy of Abbie DeSotell/Aurora Historical Society.)

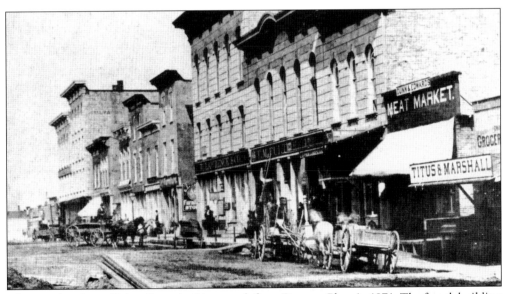

This was the view of River Street looking north from Downer Place in 1871. The fourth building from the right became the location of the Savings and Loan building. Charles J. Johnson and Francis E. Wade operated a shoe store at 6 Downer Place about 1909. They advertised Crossett shoes that "[made] life's walk easy" for 90¢ in 1912. Sencenbaugh's sold one-of-a-kind hats in 1912 for $5 and $7.50. (Courtesy of Abbie DeSotell.)

The W. W. Hichcox store is seen here around 1912. It was located at 56 South River Street for several years. In 1919, he went to work at Frazier's. (Courtesy of Bert Swanson.)

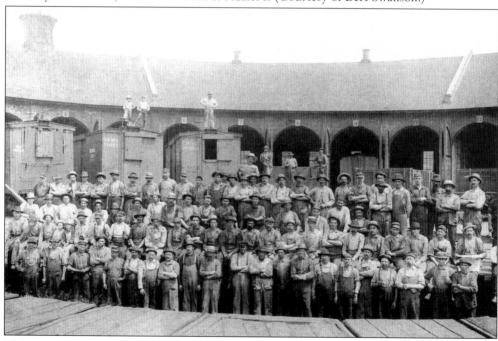

This postcard shows the Chicago, Burlington and Quincy roundhouse crew around 1890. A *Beacon* article noted that engine No. 1710 had been repaired and "will hereafter do service on the Northern division." The article, "A Collection of News Items Both Personal and Otherwise," also noted that the supply of material for the new boxcars had run short and that the new officer's car for the superintendent of the Northern division was "rapidly nearing completion." (Courtesy of Tom Deisher.)

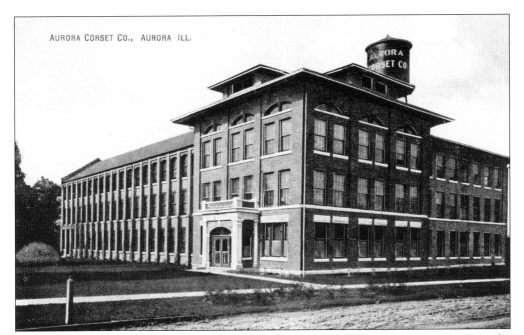

In 1909, the Aurora Corset Company offered Henderson back- and front-laced corsets for "discriminating, well-dress women who like superior style and quality." There were many models and styles starting at $1.50 to $3 and up. The company sold corsets to leading dry goods stores in Aurora and throughout the country. The earliest firm, the Chicago Corset Company, was the second-largest in the world and by 1890 produced two million corsets annually. (Courtesy of Bob Arundale.)

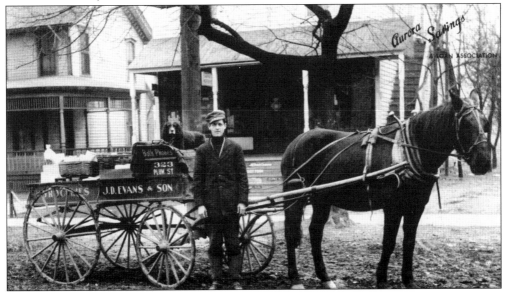

Shown here is the delivery wagon of J. D. Evans and Son with friendly dog Deliaha as groceries are delivered to the neighborhoods in the early 1900s. Charles Monselet wrote, "The pleasantest hours of our life are all connected . . . with some memory of the table." After receipt of the week's meat, milk, and vegetables, the homemakers could fashion a delicious meal for their families. (Courtesy of Bill Novotny/Aurora Historical Society.)

In order to offer something tasty for the housewives of Aurora, the Aurora Woman's Club compiled a collection of favorite recipes around 1915. The club began in 1891 and had a Charity Council as well as conducting cooking and sewing classes. A quote the author particularly likes was included in the text: "You must come home with me and be my guest, you will give joy to me and I will do all that is in my power to honor you." (Courtesy of Bob Arundale.)

A COLLECTION OF RECIPES
FROM AURORA AND VICINITY
Compiled by
The Woman's Club of Aurora

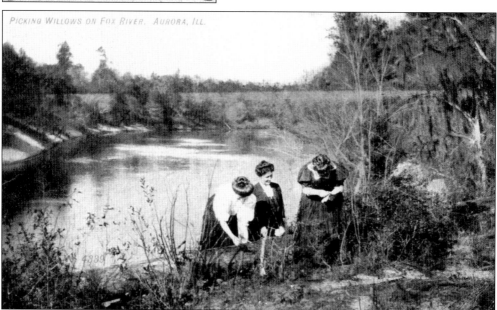

Picking willows along the Fox River looks like a fine afternoon's activity. Prior to the 1800s, the land surrounding the Fox River valley was, to a great extent, fertile prairies that supported "substantial numbers of game animals." Deer, fox, coyote, groundhogs, wild ducks, geese, raccoons, owls, and hawks could be found in abundance. Native Americans used the thorns of the thorn trees to make sewing needles and even fishhooks. The poet John Ruskin wrote, "Nature . . . works as the pride of angels to know and their privilege to love." (Courtesy of Bob Arundale.)

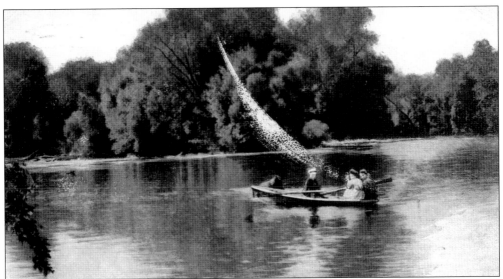

This idyllic scene of the Fox River was mailed on December 15, 1908, with the message "terribly busy and no time for any society functions." French explorer René-Robert Cavelier, Sieur de La Salle and his party were some of first to explore the Fox River valley. They explored the river valleys of Illinois from 1680 to 1683 to find alternative trade routes from the Great Lakes to the Mississippi River. La Salle passed his notes charting this area to Franquelin, the official cartographer of Canada. The Fox River has had four names in its 400 years, including Pestekouy (Algonquin for "buffalo"), Le Rocher, and the Fox River. This valley provided an abundance of life's necessities. (Courtesy of Bob Arundale.)

Two brothers pose for this postcard on September 12, 1919. Robert Ames, age six, and Roger, six months, were captured in a moment of smiling reflection. (Courtesy of the Aurora Historical Society.)

Grandfather George Hoffman and cousin Jane Hoffman enjoy a pony ride around 1935. Grandson Ken Kimmell was born on November 7, 1942, in Aurora and worked at Thor Power Tool in the 1960s. His family, as many, treasured preparations for their meals together. Laurie Colwin wrote that no one cooks alone. Even at her "most solitary, a cook is surrounded by generations of cooks past." (Courtesy of Ken Kimmell.)

A postcard was issued as Aurora celebrated its centennial during activities the week of September 5–11, 1937. A second issue was for the Fox Valley Philatelic Society in 1938. The city's history stretched over 100 years, and the legacy of those who had gone before was saluted and remembered. From covered wagon to streamlined zephyr, Aurora told a romantic story "outlining a century of progress and dedicated to our Pioneer Citizens who made such development possible." (Courtesy of Bob Arundale.)

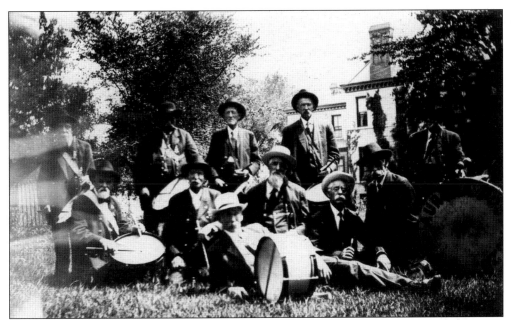

In the 1850s, the Aurora Brass Band entertained. The Aurora Cornet Band was organized in 1866. In the 1890s, Aurora had a philharmonic band. Bands at the beginning of the 20th century were marching, brass bands, or symphonic. Music could be heard in the schools and the churches as well as at many social functions. Shown is the Aurora Post No. 20 GAR Band, around 1910. (Courtesy of the Aurora Historical Society.)

"Hello, listeners, meet the boys, a bunch of swell guys" was the greeting on this postcard that was mailed on November 26, 1932. The radio was likened to the wonders o that age. A writer suggested, however, it should be "put to better use than boring the public with advertising toothpaste, borax, bunion salve, hair restorers and a thousand other concoctions." (Courtesy of the Aurora Historical Society.)

Three German ladies named Meta, Greta, and Ellinor sent this postcard to Lydia Weolhekoun in "Taylorville, Florida, Amerika." Imagine afterward that their hats were placed on the parlor table and they went outside to the verdant perfume of their rose gardens, skipping around, their curls flying. (Courtesy of Aurora Historical Society.)

Five women in the field pause for the camera around 1890. Making a dress of sufficient length, with long sleeves, high necks, and enough breadth to fit the hoopskirts and bustle required 12 to 15 yards of fabric. Velvet or straw hats were adorned with flowers and stuffed birds. Shoes were high buttoned or laced. In 1895, the Gibson girl swept into vogue. Skirts had less material and shirtwaists were high necked. The ensembles included velvet bonnets and a frilly parasol. (Courtesy of the Aurora Historical Society.)

Seven

Education in the City of Lights

Memory, what wonders it performs in preserving and storing up things gone by—or rather, things that are.

—Plutarch (AD 45–125)

The township of Aurora occupies the southeast corner of Kane County and borders on DuPage County to the east, Kendall County on the south, and corners on the northwest of Will County. This land was the favorite home of several tribes of Native Americans who lived comfortably on the wooded banks of the Fox River, whose placid waters furnished them an abundance of fish. The Winnebagoes, Sacs, Foxes, and other tribes have at times made their homes in or near Aurora. The native peoples left the graves of their ancestors behind, and several mounds in Aurora and vicinity were found to be burial grounds.

Shortly after the Civil War, when Germany's Otto Eduard Leopold von Bismarck's war with France was under way in 1870, several hundred families came from the southern part of Luxembourg, the Ruhr region, and other industrial areas. They brought with them their knowledge of the crafts. The Chicago, Burlington and Quincy shops were ready to hire them. The shops needed boilermakers, carpenters, cabinetmakers, and molders. This exodus of working people changed the pattern of living for those who farmed in the area. The immigrants, along with hundreds of others, found their services needed, and the city experienced great growth. They included Olinger and Hankes (men's clothing), John Jungels (shoes), and Kartheiser Brothers (hardware), as well as John Thielen (coppersmith) and Peter Faber (cabinetmaker). With the advent of the 10-month school year and the promotion of friendly competitive contests such as baseball and bowling, social events took place on Sunday afternoons. With plenty of money and a 59-hour workweek, Aurora residents experienced a growing prosperity. A study conducted during the Depression found that the northeast area of Aurora, where these families lived, had one of the highest percentages of home ownership in the state. Although a minority group, they made no demands on the economy for their sustenance.

In 1908, a summary of improvements included a waterworks system with over 58 miles of water mains. Its value was over $200,000. There were 500 fire hydrants all without any tax on the city. There were 50 miles of sewers and 92 miles of streets. Eighty-five miles of brick and cement sidewalks were in place. The fire department had five hose houses and a good municipal streetlight system was evident. There was an excellent school system with ample school buildings.

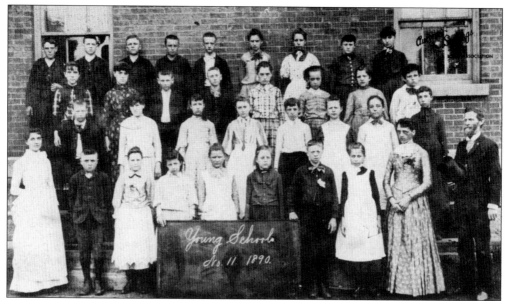

The students at the D. W. Young School in 1890 look rather serious. The school was located in the 400 block of Fifth Street. It burned in 1956. The teacher in white (left) is Ruth Beaupre. The gentleman at right with the stovepipe hat is Professor Joseph H. Freeman. (Courtesy of Bill Novotny/Aurora Historical Society.)

Notice the double desks at the D. W. Young School around 1900. School buildings were surrounded by "suitable lawns and play grounds, well paved and shaded." The people of Aurora were natural tree culturists, and their spirit was shown "throughout the city in both a public and private manner." (Courtesy of John E. Hurt.)

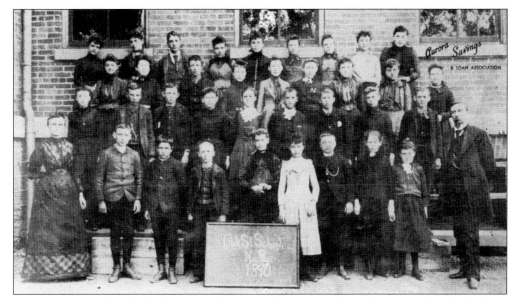

Oak Street School in 1890 is shown on this postcard. It is now called Mary A. Todd School. Mary Burns was the teacher, and Frank Hall, right, was the principal. In 1890, enrollment was 2,344 on the east side and 1,014 on the west side. (Courtesy of Bill Novotny/Aurora Historical Society.)

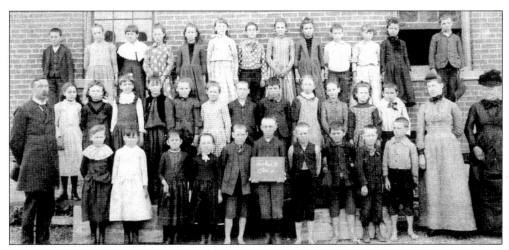

The Lake Street School (Lincoln) is shown here around 1885. West Aurora School District No. 129 dates from 1836 when a school opened in a shanty at the foot of Claim Street. Tuition was $1.50 per child. In 1852, Oak Street School was built. West's first high school (1868) was held on its top floor. Branch School was built on South Lake Street in 1865. It burned down and was replaced by South Lake Street School in 1891. The school's PTA, formed in 1911, worked to move lavatories indoors. (Courtesy of Dr. James Rydland/Aurora Historical Society.)

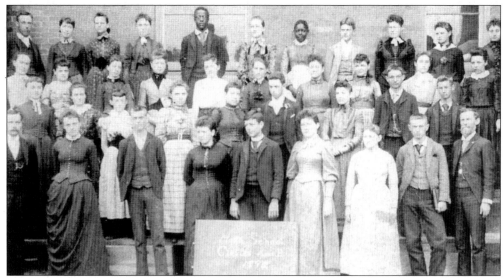

Although classes began in 1868, the high school did not have its own building until 1906. It had occupied part of Old Stone and, later, Oak Street Schools. The first four-year course of study began in 1893. During commencement in 1906, the West High seniors learned that the high school (Oak Street) was burning. The first West High, built in 1906 at Galena and Blackhawk Street, later became Franklin Junior High. In 1953, the high school moved from the old structure on Blackhawk Street to its present location on Galena Boulevard. (Courtesy of Dr. James Rydland/Aurora Historical Society.)

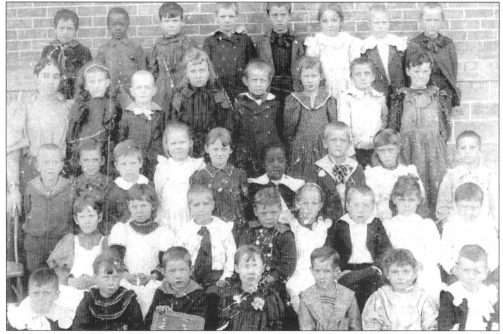

In 1889, the one-room Pennsylvania Avenue School was completed at a cost of $5,652. The 1907 curriculum included reading, history, spelling, writing, drawing, music, insects, weather, birds, and geography. In 1913, the name changed to Illinois Avenue School. Then, in 1928, it was renamed after Nancy Hill, a veteran teacher. (Courtesy of Dr. James Rydland/Aurora Historical Society.)

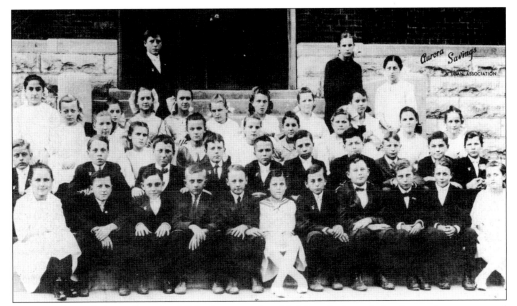

In 1919, the eighth grade at St. Nicholas poses for this historical card. As the students prepared to graduate, they rejoiced in shared experiences and mutual comforts. St. Nicholas was founded in February 1861 on the corner of High and Liberty Streets. (Courtesy of Bill Novotny.)

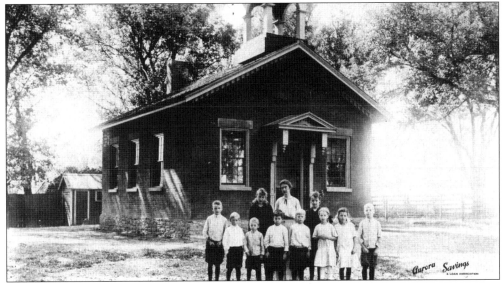

The red brick schoolhouse, seen here around 1915, at Galena and Edgelawn Drive was built in 1882. The one-room schoolhouse had 24 scholars. A potbelly coal stove provided heat, and at Christmastime, students participated in a 10¢ gift exchange. The janitor was paid $2.50 monthly. Outdoor plumbing and a bucket and dipper for drinking water were standard at that time. (Courtesy of Bill Novotny.)

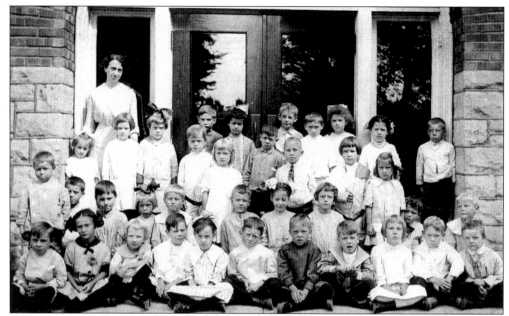

Galena Street School was built in 1906 during the tenure of superintendent A. V. Greenman, whose name later would be given to the school. A new building replaced the older structure in 2004. Principal Erin Slater and assistant principal Emily Tammaru led the student body of 561 children in 2005–2006. Waubonsee Community College has offered both Adult Basic Education (ABE)/General Educational Development (GED) and English as a second language (ESL) classes at this location. (Courtesy of Dr. James Rydland/Aurora Historical Society.)

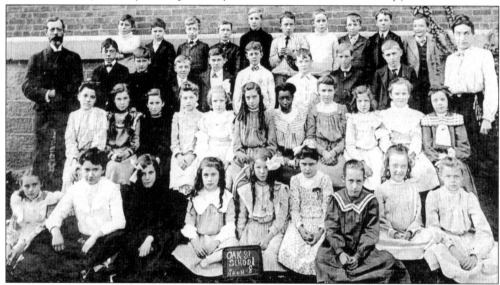

When Old Stone School burned down in 1884, it was replaced with Oak Street School. At the dedication, a board member said, "The low, the high, the rich, the poor, all stand on common footing which the common school provides. There is no nobler institution in the land than the public free school." In 1921, the school was named after Mary A. Todd, the West High class of 1872 valedictorian and a renowned educator. (Courtesy of Dr. James Rydland/Aurora Historical Society.)

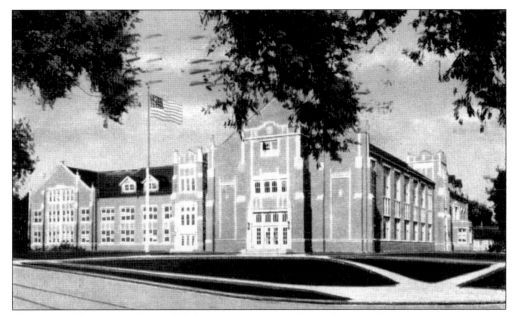

This is a 1939 view of Bardwell School. East Aurora School District No. 131 became the first free school system in Illinois under a special act of the legislature in 1851, two years before the free school laws passed. The first school opened in 1836 by subscription organized by Roswell Wilder. By 1851, a tax was voted for a levy of one percent to build a new schoolhouse. C. M. Bardwell School was built in 1929 at 550 South Lincoln Avenue. (Courtesy of Bill Catching.)

The 50th anniversary of Clifford I. Johnson School will be celebrated in 2006. Clifford I. Johnson School opened its doors in August 1956 on Liberty Street Road. The first principal was Sylvia Emma Kersey. Today there are 317 students enrolled in kindergarten through the fifth grade under the leadership of principal Kelly McCleary. The school secretary is Rita Zuponeck. (Courtesy of Kelly McCleary.)

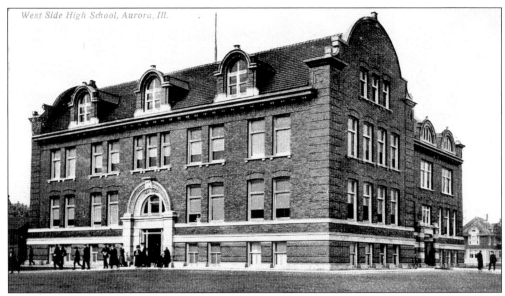

This postcard was mailed on May 15, 1909, and depicts West Aurora High School. The high school course was considered comprehensive and complete at that time. "The high character of the public schools of Aurora, and the degree of perfection to which the high school courses have been brought, have given the city a state reputation in educational circles." (Courtesy of Bob Arundale.)

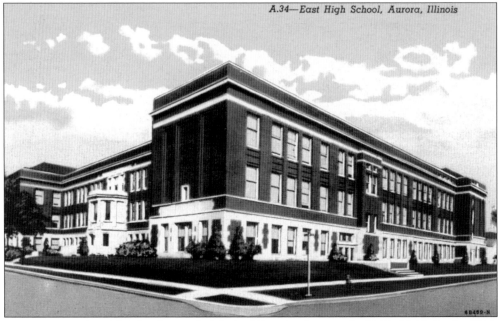

A.34—East High School, Aurora, Illinois

In 1912, East Side High School occupied the building that became the K. D. Waldo Junior High in 1957. That year, the new East Aurora High School building opened at Fifth Avenue and Smith Boulevard. It was noted in 1912, "Complete boards of education have provided for the both school districts in every department. Fine geological cabinets have been supplied and large collections of stuffed mammals, birds, reptiles, batrachia and fishes are held. There are splendid libraries, each entirely complete, one east, and one west of the river." (Courtesy of Steven Solarz.)

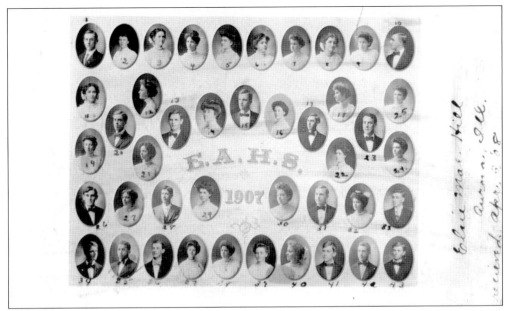

The graduating class of East Aurora High School in 1907 is shown on this postcard. The course of study is managed "by the present and able courteous management. The various branches in science, mathematics, language, and history are joined with special teachings in drawing, music and elocution, with courses also in both Latin and German." In 1890, a postgraduate course for teachers was held at East Aurora High School. (Courtesy of the Aurora Historical Society.)

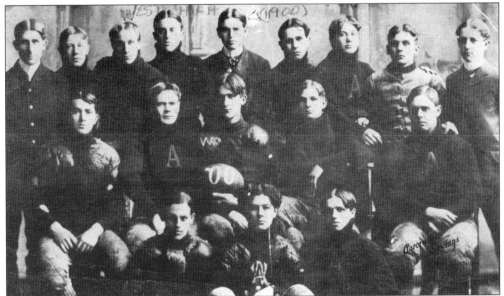

The West Aurora High School team, seen here around 1900, was defeated by East Aurora High School 17-0 in the football game that year. The rivalry between the schools is one of the oldest in the state. In 2000, they played the 107th contest since the first meeting in November 1893. Basketball competition between East and West began in 1912. In 2006, the West Aurora Blackhawks won the regional final 64-58 over the East Aurora Tomcats. In the Class AA East Aurora sectional, West won over Batavia 63-57. (Courtesy of Bill Novotny/Aurora Historical Society.)

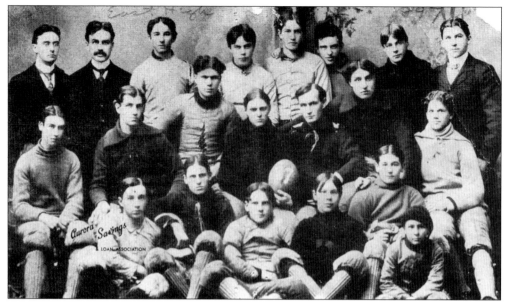

The East Aurora High School football team of 1897 is pictured here. There was no game between East Aurora and West Aurora High School that year. In 1909, over 6,000 watched the East-West football contest. By 1926, they played at the West field in the grand tradition of their sporting events. (Courtesy of Bill Novotny/Aurora Historical Society.)

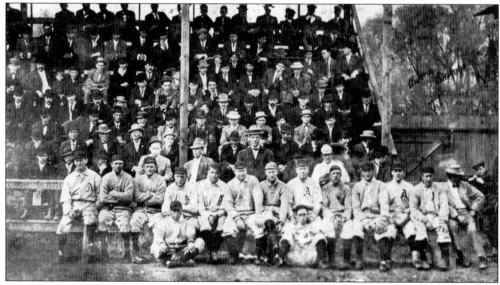

The Aurora baseball team around 1910 is shown here at Fox River Park. The first club in Aurora was the Ponies, organized in 1875. Most of their games were played in the Pigeon Hill area. In 1880, the Burlington Railroad employees organized the Red Stockings. In the early 1900s, clubs included the Kane Streets, the South Ends, and the Acorns. Casey Stengel played with the Auroras until a Brooklyn scout saw him in 1911, and Casey was on his way to fame. (Courtesy of Bill Novotny.)

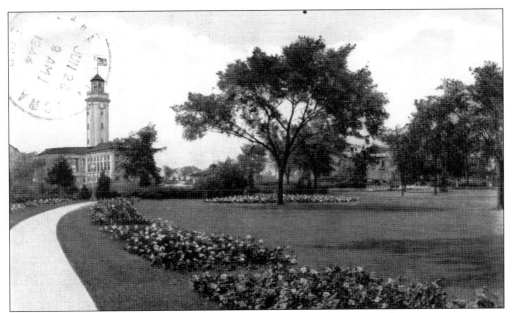

Mooseheart is the Loyal Order of Moose school grounds and complex that was dedicated on July 27, 1913. Vice president of the United States Thomas R. Marshall delivered the dedicatory message. "Child City" is situated on 1,109 acres of land just north of Aurora, and the grounds are laid out in the form of a heart. Each child admitted has lost one or both of his or her parents. On April 15, 1914, the first concrete mile of the Lincoln Highway was laid in front of Mooseheart. (Courtesy of Bob Arundale.)

The idea of a child city was introduced by James J. Davis, an iron puddler from Pennsylvania. Alaska, Purity, Davies, and Progress Halls were among the first buildings. Formal education began in nursery school at age three. Elementary and high school courses are supervised by the State of Illinois. Mooseheart is a member of the North Central Association of Colleges and Secondary Schools. These nursery children are shown at Mooseheart around 1915. (Courtesy of the Aurora Historical Society.)

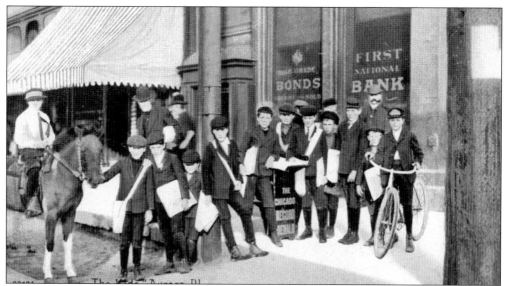

In 1890, Aurora had nine newspapers. The *Aurora Beacon* was established in 1846 by Myron and Benjamin Hall. The *Herald-Express* began in 1866. The *Aurora Volksfreund* began in 1868. The *Aurora Daily News* published daily starting in 1873. The *Evening Post* began in 1877. The *Aurora Blade* began in 1881, the *Daily Express* in 1883, and the *Aurora Sun* in 1886. Aurora's *Daily Democrat* was established in 1888. Shown are "the kids" delivering the newspapers in August 1908. (Courtesy of Bob Arundale.)

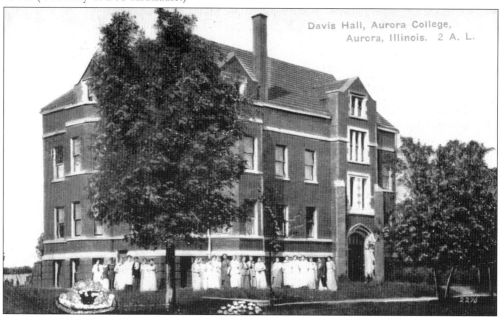

Aurora College traces its origins to the 1893 founding of a seminary in Mendota. The institution soon adopted a broader mission and moved to a new campus in Aurora in the spring of 1912. At that time, there were eight instructors. Dr. Orrin Roe Jenks was selected president of the college. In 1985, the college was rechristened Aurora University. Shown is Davis Hall, a dormitory for girls. It was built with funds donated by D. A. Davis of California in 1911–1912. (Courtesy of Bob Arundale.)

The Illinois General Assembly, through the Education Reform Act of 1985, established the Illinois Mathematics and Science Academy, the brainchild of Nobel laureate Dr. Leon Lederman, Gov. James R. Thompson, and business and education leaders. The Illinois Mathematics and Science Academy is the nation's only three-year public residential high school for students of exceptional talent in math and science. The academy's first class of 168 students graduated in 1989. Academy president Stephanie Pace Marshall lead the 650 students enrolled as well as 56 faculty members in 2006. (Courtesy of Brenda Buschbacher.)

Waubonsee Community College began on August 22, 1966. Planning for the college was initiated on February 1, 1967, when the first president, Dr. James H. Nelson, began assembling a staff and developing a multilevel curriculum. The name "Waubonsee" means "early dawn" or "early day" and was chosen as a result of a district-wide contest. The installation ceremony of the fourth president of Waubonsee Community College, Dr. Christine J. Sobek, was held on November 4, 2001. (Author's collection.)

a Vision of Life and Learning

Waubonsee Community College opens the door of knowledge, sparks imaginations, and enlightens lives through learning. We welcome the diverse abilities, goals, and experiences of individuals standing on the threshold of discovery. Our success is defined by the dreams we help shape, the opportunities we help design, and the futures we help create.

Adult
Mak

Wau...
Proje...
annive...
commu...
awards...

August 30. Aurora mayor... O'Connor, shared a procla... mayor Thomas J. Weisner... Literacy Day" in the city. T... address was given by Dr. Laurie Elish-Piper, associate professor of Reading and Literacy and Reading Clinic director at Northern Illinois University.

"Make a Difference" awards were given to Lorraine Martens, Aurora, literacy volunteer for 18 years; Diane Christian, Aurora, director of the Children's Department at Aurora Public Library, in recognition of 20 years of collaboration with WCC's Adult Literacy Program; Townsend Way of Aurora, literacy volunteer for 13 years; and Elana Petrova of Aurora, literacy student.

The mission of Waubonsee's Adult Literacy Project is to empower adults to be responsible citizens and parents through the process of improved literacy skills. The Adult Literacy Project trains volunteers to teach adults to read, write and speak English. Since its beginning in 1985, the project has served 19,145 adult students with volunteers contributing 171,995 hours of their time. Over the past 20 years, the project has won 54 local, state and national awards.

Since its beginning in 1985, the project has served 19,145 adult students with volunteers contributing 171,995 hours of their time.

...001 adults are served in family literacy programs...

...and over $5 million has been raised in grants and donations!

Office of the Mayor

Proclamation

Waubonsee Community College "Adult Literacy Project" Day

August 30, 2005

Thomas J. Weisner, Mayor
Aurora, Illinois

Making a Difference: Diane Christian (left), director of the Children's Department at Aurora Public Library, receives a Make a Difference Award recognizing her 20 years of collaboration with WCC's Adult Literacy Project from Jo Fredell Higgins (middle), WCC's Adult/Family Literacy manager, and Dr. Deborah Lovingood, executive vice president of Educational Affairs/Chief Learning Officer at WCC.

Waubonsee Community College will celebrate its 40th anniversary in 2006. The Sugar Grove campus features 11 permanent buildings with 123 classrooms, several conference rooms, a library, teleconferencing facilities, specialized laboratories, an observatory, and a two-mile nature trail. The Aurora campus opened in 1986 and includes 33 classrooms. Waubonsee's third campus opened in 1997 at Rush-Copley Medical Center adjacent to Route 34. A Plano campus will be under construction soon. (Author's collection.)

Eight

The Immigrant Experience

Our ability to reach unity in diversity will be the beauty and the test of our civilization.

—Mahatma Gandhi (1869–1948)

Tribes of Paleo-Indians lived in Illinois as long ago as 8000 BC. By 2000 BC, the cultivation of plants and use of ceramics were known to village dwellers. Between 500 BC and AD 500, skilled craftsmen practiced a limited agriculture, developed an elaborate social structure, and constructed burial mounds. When explorers arrived in the 17th century, seminomadic tribes roamed the central prairies.

The prehistoric American mastodon, genus *Mammut americanum*, once roamed the Aurora area. The mammal had crossed the Asian route in the Miocene times, before the epoch of the glaciers. The mastodon was about 25 feet long and 10 feet high. Its cranium measured three and a half feet long by almost three feet wide. Its tusks were nearly nine feet long. Remains have been found in the Fox River valley that trace to 10,000 years ago. Civil Works Administration workers made extensive finds in 1934 during the digging out of the old lake bed in Phillips Park. The lake bed, which had been filling up since Pleistocene times, disclosed three gigantic skulls, four tusks, a 92-pound lower jaw, and numerous bones. A sculpture in bronze by Erik Blome was dedicated on September 30, 2005, near the Phillips Park Visitor's Center to commemorate the 1934 dig.

As early as the 1600s, Native American tribes lived in the Fox River valley. Large fording rocks were used to cross the river. Chief Waubonsie was the leader of the Potawatomi tribe. His tribal village was composed of movable wigwams, as the tribe was a nomadic people. In 1829, a treaty had given Potawatomi chief Waubonsie five sections (10 square miles) of land in the Aurora area. When Joseph McCarty arrived, the area was known as Pottawatomie Reserve. In 1828, there were 51 inhabitants of Chief Waubonsie's village. Waubonsie's character was well known to be that of a warrior of uncommon daring and enterprise and a chief of great intelligence and influence. In council, he was said to be shrewd, reserved, and cautious in conclusions and decisions. His voice was as deep as the saxophone's moan. He stood six feet four inches, weighing 200 pounds. His wife was very heavy, fat and square, of medium height, wrote Samuel McCarty.

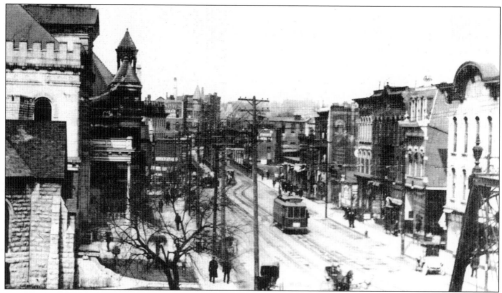

The state of Illinois originated from the Algonquin Indian word "Inini," meaning "proud man." The French translated it "Illini" and added the suffix "ois," meaning tribe. Illinois was admitted as the 21st state in the Union in 1818. Aurora is the Roman name for Eos, the Greek Goddess of the Dawn. This view is looking west on Fox Street (Downer Place) from the east bridge in the early 1900s. (Courtesy of Abbie DeSotell.)

Abbie Reuter was born to German parents on November 12, 1917, and wed Albert DeSotell (born October 13, 1916) on June 28, 1952, at St. Joseph's Church, Fr. Joseph Weitkamp officiating. They enjoyed a honeymoon to Minnesota and had two children, Kathryn and Mary Ann. Albert, of French ancestry, worked in the Burlington railroad shops in the platting area, and Abbie had been a payroll clerk for 18 years at Oatman's Dairy before her marriage. Abbie passed away on June 22, 2006, at her home. (Courtesy of Abbie DeSotell.)

One of three daughters of Joseph G. Stolp was Caroline Stolp Johnson, who recalled in 1937 that as a girl she had picked wild crabapple blossoms on her father's island. A 24-foot fill had to be made on that part of the island before streets could be graded and hotels erected. Her brother Myron became city engineer and created many inventions, including the original key control for the chimes at Cornell University. This postcard shows Ethlyn Gibson in 1905. (Courtesy of Judy Kenyon.)

QMSgt. John Hankey is shown (back) here with Carl Hankey (front, left) at an encampment around 1917. World War I was in full swing. Aurora remembered its soldiers and sailors with a Christmas check for $5. Each employed citizen of Aurora was asked to contribute one hour's pay per week as a regular contribution to the war chest. The Knights of Columbus raised $18,000 and the sale of thrift stamps raised $61,000 in 1918. (Courtesy of the Aurora Historical Society.)

Two servicemen and their dates were enjoying a relaxing picnic. Aurora had sent more than 1,500 boys and girls to military service by 1918. Each man was given a Red Cross kit before he boarded the train, along with a sweater, neckchief, and wristlets made by the patriotic women of Aurora. Aurora had contributed more than $3,000 to see that each man had plenty of armor plate, bullets, and substantial meals. Aurora, "in her war dress, was an inspiring spectacle." (Courtesy of the Aurora Historical Society.)

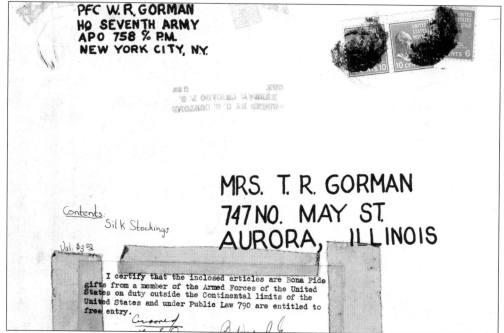

A package containing silk stockings was mailed to Mrs. T. R. Gorman by her son Pfc. W. R. Gorman during the winter of 1918. (Courtesy of Erv and Charlotte Gemmer.)

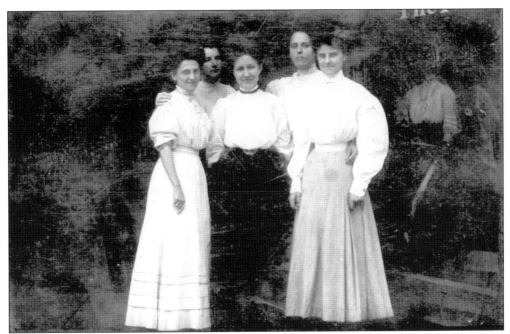

In 1893, five Aurora women of different heritage pause for this picture. Of Irish, Swedish, Italian, German, and Welsh backgrounds, the women knew what setting up a household in a new city meant. With open hearts, they extended friendship to one another. "A loving heart is the beginning of all knowledge," wrote Thomas Carlyle. (Courtesy of the Aurora Historical Society.)

"It's not that I belong to the past, but the past that belongs to me," wrote Mary Antin. Like many women before them, this unidentified mother and daughter resemble each other. The comfort they gave to each other was living testament to their shared Italian heritage. This postcard is from around 1900. (Courtesy of the Aurora Historical Society.)

This unidentified little girl and boy are pictured around 1910. September had arrived with its crisp air and yellow sunshine that year. Certain it was that these two children were dressed in their best clothes. (Courtesy of the Aurora Historical Society.)

An unidentified beautiful baby sits pensively around 1910. She might have eaten homemade bread from the W. T. Meagher and Company bakery at 38 Downer Place or enjoyed a peppermint candy from Paulos Brothers' Parlors, which advertised as "The Coolest Spot in the City" as it sold delicious confectionery, exquisite sodas, and ice cream. (Courtesy of the Aurora Historical Society.)

Shown is an unidentified, but prosperous gentleman of Aurora around 1910. Confucius wrote that "A man of humanity is one who, in seeking to establish himself, finds a foothold for others and who, desiring attainment for himself, helps others to attain." (Courtesy of the Aurora Historical Society.)

The woman seated on the right is Ida Roesner, pictured in 1905. The other three could be her sisters and brother. (Courtesy of Ron and Carolyn Roesner.)

Shown is an unidentified Aurora family in 1924. One could imagine that during their courtship, many evenings were enjoyed listening to the radio and the couple might have chosen their favorite song, which could have been the 1924 hit by the Isham Jones Orchestra titled "It Had to Be You." (Courtesy of Judy Kenyon.)

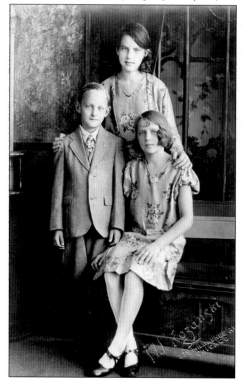

Three unidentified Polish children are pictured here in the 1930s. The simplicity of their presence suggests friendship. Would they shop at the Biever Furniture Company at 61 North Broadway for family gifts, or buy a tailored polo coat that was so smart looking in 1930? (Courtesy of Judy Kenyon.)

Were these young coeds "mortal, guilty and entirely beautiful" as a poet suggested? What course of study intrigued them? Five juniors at Aurora College smile around 1910. Did they listen to the *Garden Hour* on WKYW sponsored by Erlenborn's? (Courtesy of Judy Kenyon.)

This postcard shows the first communion class at St. Nicholas School in the 1940s. The dresses for the girls were sold at the Aurora Dry Goods Company for $3.44. Their white socks in a sheer seven-thread weight sold for 79¢. The shirts for the boys in fast colors and non-wilt collars sold for 39¢. (Courtesy of Dave Linster.)

An unidentified Dominican nun is shown on May 2, 1940. Earlier that day, she had fashioned daisies, roses, and lilies of the valley for the altar arrangements. The weather forecast for that early May day was for a high of 37 degrees with a light frost predicted. (Courtesy of Dave Linster.)

Children of the Nick Welter family pose in the 1940s. Were they dining that afternoon on veal stew from Heins Market at 58 North Broadway Street? Did fresh cottage cheese at 5¢ a pound interest their palates? Ready-to-serve picnic ham was 19¢ a pound at Boyd's on Main Street. The telephone number was 2-2000. (Courtesy of Dave Linster.)

This Thanksgiving Day photo postcard was taken on November 26, 1914. At the top is Margaret Linster. Pictured from left to right are Mayme Linster, Margaret Wagner, and Katherine Linster. Their family illustrates the phrase "For these and all the other things / Were part of you and me." (Courtesy of Dave Linster.)

The street suggests a busy downtown. Just around the corner since 1867 was Sencenbaugh's. Located at 20–22 South Broadway Street, the store was known for quality merchandise. Mr. Sencenbaugh was regarded as retiring, congenial, sympathetic, and kind. He died in 1925. The store's telephone number was TWinoaks 7-4621. (Courtesy of Joyce Dugan.)

Marie Wilkinson arrived from Louisiana with husband Charles more than 70 years ago. She was cofounder of the Aurora Human Relations Commission, the Feed the Hungry Program, the Health Referral Service at the St. Vincent DePaul Center, and the Marie Wilkinson Child Development Center. In the 1960s, she gained local prominence in the civil rights movement by helping to raise $12,000 for the cause. In 2001, she received the Catholic Church's highest honor for American missionary work, the Lumen Christi Award. (Author's collection.)

The Ballet Folklorico Quetzalcoatl presented a fantastic show at the Paramount Arts Centre on September 17, 2005. Over 62 performers appeared, including award-winning singer Goyo Cruz and the Rodalla Alma Bohemia Acoustic classical guitar troupe. The 1900s saw a great wave of Mexican workers arriving here as railway companies searched for laborers to work on the first transcontinental railroad. Today Aurora's population is about 40 percent Hispanic. The Hispanic Chamber of Commerce is currently led by Zaida Chapa. (Author's collection.)

Caledonia "Anty" Jackson is shown here in a reflective pose on this book cover. Jackson worked as a domestic for Caroline Potter around 1915 at Potters' fine boardinghouse that was located at 59 South Fourth Street. This photograph was taken by J. P. Hambly, and he entered this photograph in a local contest in 1913 under the title *Aunty Jackson's Reverie*. (Author's collection/original Aurora Historical Society.)

Isabelle Landry, referred to as the "little French girl who sang for Abraham Lincoln," recalled meeting him in 1851 at the Charles Hoyt store on River Street. "Judge Pinney and a tall stranger entered the shop just as Mr. Hoyt was wrapping up my parcels. He was so tall and wore such a tall hat. The stranger was Mr. Lincoln. Charles Hoyt said to Lincoln, 'that little girl can sing in French' and Mr. Hoyt asked me to sing for them and I agreed." This postcard shows the Great Emancipator in front of the White House in 1863. (Courtesy of Myron Nelson.)

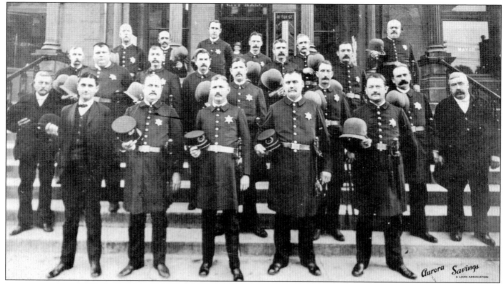

Law enforcement was initiated in 1835 when Ralph C. Horr was elected justice of the peace and B. F. Fridley was appointed constable. In 1866, George Fish was elected marshal by the city council and served until 1870. Sam Charles, a city alderman, purchased a team of horses and Aurora's first patrol wagon in 1886. In 1912, the city purchased its first paddy wagon, a 1912 Kissel Kar. In 1914, Anne Forsythe became the first policewoman. Deborah Porter began her 27-year career in May 1971 as the first female cadet. Aurora police officers are shown here in a 1903 postcard. (Courtesy of Abbie DeSotell/Aurora Historical Society.)

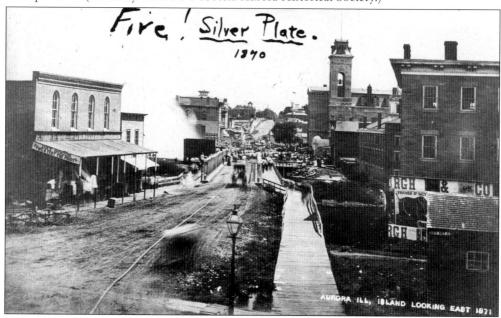

The Aurora Silver Plate Manufacturing Company was founded in 1869 by several local dignitaries, including Joseph G. Stolp. From the start, Aurora Silver Plate employed nearly 200 men and remained prosperous for more than 40 years. The wooden building burned nearly to the ground on July 31, 1871. Construction began on a new building in 1871. The architect was A. H. Ellwood. (Courtesy of Bert Swanson.)

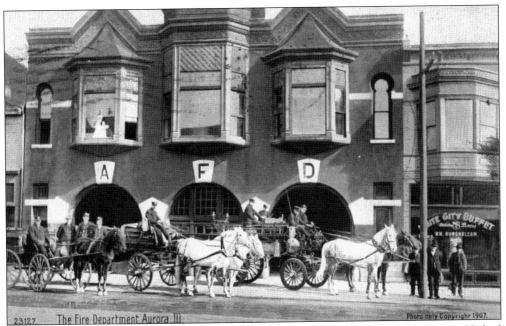

After several major fires in Aurora in 1856, a meeting of volunteer members on July 1 established the Young America Fire Engine Company No. 1 with Jesse Brady as foreman. A hand-pulled, hand-pumped fire engine, hose cart, and 500 feet of hose were purchased. By 1906, there were 40 firemen, fully paid, on five hose companies, a hook and ladder truck, and the chief. This postcard is from around 1907. (Courtesy of Bob Arundale.)

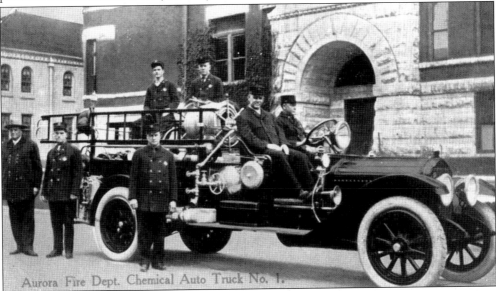

In the early 1870s, the city was divided into fire districts. A bell was installed over the courthouse/city hall for fire alarm purposes. Nine strokes of the bell meant a fire, followed by a number of strokes indicating the district. Shown here in this *c.* 1911 photograph is the first motorized vehicle of the Aurora Fire Department. It cost $10,000 and was used until 1988 as the central fire station. The building reopened as the Aurora Regional Fire Museum in 1990 and is designated an historic landmark by the Aurora Preservation Commission. (Author's collection.)

Florence Unfried is pensive around 1927. She graduated from East Aurora High School and was dating Ed Novotny during the summer of 1929. Did she know Helen Sparks, who was the first Aurora Red Cross nurse to arrive in France? Sparks had been witness to men who had served valiantly. (Courtesy of Bill Novotny.)

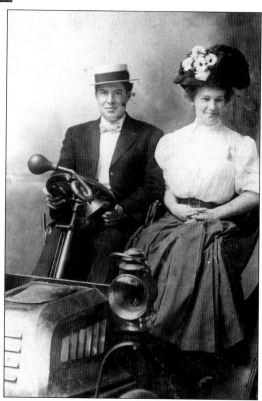

Sweethearts Albert and Clara Unfried (née Schoenhofen) were wed in November 1908. (Courtesy of Bill Novotny.)

Nine

REJUVENATION 2006

The ideals, which have lighted my way and time after time have given me
new courage to face life cheerfully, have been Kindness, Beauty and Truth.

—Albert Einstein (1879–1955)

The fabric of life in Aurora by 1945, like a beautiful swathe of silk, was pleasing. "This was the promised land," said John Jaros, executive director of the Aurora Historical Society, which was founded in 1906. "Aurora had fertile land and lots of it. Industry attracted a lot of people and the city had a major influx of immigrant groups." The Aurora Historical Society is located at Cedar and Oak Streets in an 18-room pre–Civil War mansion. Thousands of artifacts include the Blanford clock, pieces of china and silver, photographs, sewing machines, Victorian-period furnishings and decorations, spinning wheels, bicycles, and buggies. Chief Waubonsie's moccasins are displayed along with other Native American artifacts.

In the 1945 Illinois Bell telephone book for Aurora, three banks are listed. They are the Aurora National Bank, the Merchants National Bank, and the Old Second National Bank. There are, however, 14 bakeries listed, among them the Ericson Swedish Bakery on North Ohio Street and the Loose Wires Biscuit Company on South Lake Street. There are five Higgins families listed, including a John, a Robert, and a Thomas. Other occupations that advertised are Baby's Valet Diaper service, dressmakers, livestock farm stores, mushroom farms, tearooms, and upholsterers. By 1946, the population of Aurora was 47,170, and the average American man could expect to live 64.4 years. In 1971, there were 75,000 residents, and by 1980, there were 82,000. Aurora comprised 27.24 square miles in 1980 and had 98,590 telephones in service.

The population currently comprises 157,476 residents, encompassing nearly 39 square miles of land in Kane, DuPage, Kendall, and Will Counties. Aurora is an ideal location for regional retail and entertainment venues. More than 50 percent of the households within a 15-mile radius of downtown have a household income of $75,000 or more. Aurora is home to more than 20 significant historic structures, including many outstanding examples of terra-cotta work. The city has grown to be a business and service economy, with high-tech, banking, social, and educational opportunities for the 21st century. The founders of Aurora might have been inspired by this lovely thought from Romania: "We are all wanderers on this earth. Our hearts full of silver song. Our pockets deep with dreams."

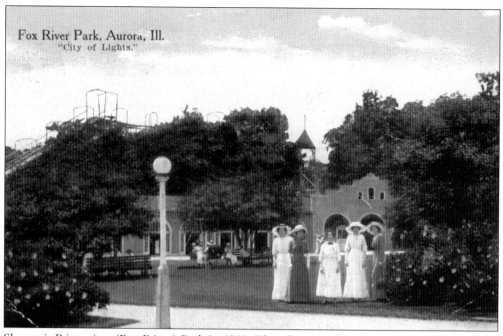

Shown is Riverview (Fox River) Park in 1919. This playground had a dance pavilion, a roller coaster, a merry-go-round, rowboats, a passenger boat, and a baseball diamond where teams of the Illinois-Wisconsin League played. Every summer, tourists rode the Chicago, Aurora and Elgin electric cars to Aurora, transferred to waiting open streetcars, and headed to Riverview Park for the day. In 1921, the Exposition Amusement Park opened on North Lake Street and by 1925 Riverview was closed. (Courtesy of the Aurora Historical Society.)

Progressive Aurora turned on the lights on the west side with much fanfare on November 21, 1908. Citizens called it "the Great White Way." A *Beacon* article described the scene: "River Street was thronged with one solid stream of merrymakers." A few weeks later, the east-side lights were turned on, then representing 16 blocks of lighting. Indeed, it was the City of Lights. This postcard shows a beautiful sky overhead around 1950. (Courtesy of Bob Arundale.)

The Aurora Historical Society celebrates its 100th anniversary in 2006. Built in 1856–1857, the Tanner House was originally the home for William Tanner, a prominent Aurora hardware merchant. On March 25, 1936, the Tanner House was donated to the Aurora Historical Society. This 18-room brick Italianate structure features ornamental plaster work and the original gaslight fixtures. (Courtesy of the Aurora Historical Museum.)

This postcard depicts Dr. George and Clara Dienst and two-year-old uncle George Morris around 1925. Dr. George and Clara lived on Maple Avenue and George and family lived on Lafayette Street in Aurora. George grew up with a passion for the theater. After serving in World War II in England, he moved to New York in 1946. He later became an agent with clients like Peter Falk, Christopher Plumber, Jean Stapleton, James Broderick, and many others. He died of a heart attack at age 46. (Courtesy of Carolyn Roesner.)

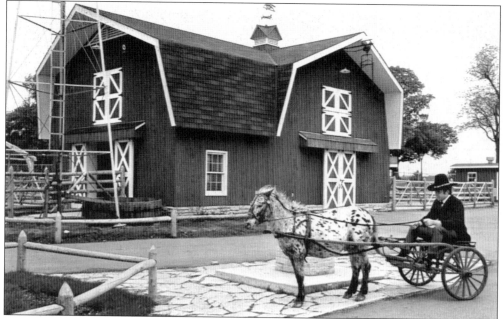

Blackberry Farm, run by the Fox Valley Park District, opened in 1969 as a living history museum, first known as Pioneer Park. There is the old blacksmith shop, a one-room schoolhouse, a charming town square with the Huntoon House Hotel, Frey's Saloon, a Discovery Barn area, and Carriage House Museum. The old engine No. 9 chugs into the station for passengers to journey around the lake, making a stop at the Pioneer Log Cabin. (Courtesy of Bob Arundale.)

In August 1973, over 4,000 acres of land began to be developed on Aurora's far-east side. Fox Valley Center opened with the Sears store in February 1975. Savannah's was the imaginative creation of Dee and David Davenport, who opened the restaurant with a southern-style tearoom in 2004. Adagio Teas, a national directory of establishments providing tea service, named the restaurant top-rated in Illinois for its afternoon tea service. The tearoom relocated to a new location in the spring of 2006. (Courtesy of Bob Arundale.)

Since relocating from the Chicago area to St. Charles in 1980, John and Evelyn Clark have offered experienced repair and restoration of stained, leaded, and beveled glass windows and lamps. They have designed, fabricated, and installed traditional and contemporary, residential, commercial, and church art glass throughout the Fox Valley area. Since 1996, their studio has been located at 28 South Stolp Avenue in Aurora. (Courtesy of John and Evelyn Clark.)

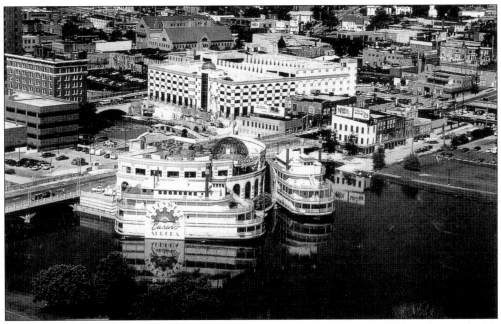

Hollywood Casino Aurora held ground-breaking ceremonies on May 5, 1992, and opened with a "Puttin' on the Ritz" theme in July 1993 with a pair of riverboats. In June 2002, the two riverboats were revamped and replaced with a 53,000-square-foot facility on one floating level. The casino includes 18-foot-high ceilings, 1,120 slot machines, and 27 gaming tables. There are about 2.4 million visitors yearly. (Courtesy of Joe Behm.)

Ron Stewart Portraiture was named in 1996 a Fellow of the British Institute of Professional Photography. An Aurora native, Stewart specializes in portrait and wedding photography. His splendid first wedding photographs were taken in 1958. He has had 85 prints accepted in international competition as a member of the Professional Photographers of America. Nika (left) and Tasha Orlovsky from Boston in 1994 are shown. (Courtesy of Ron Stewart.)

Imagine that a quiet resident people, an order-loving population, a cultured and refined midwestern society have built prosperous Aurora. Then one will know the truth of this august city, Aurora. With their hearts and hands, the immigrants of Aurora began a grand tradition of achievement. To those who came before, a benediction of thanks are offered. To them, this day, it is acknowledged that admirable Aurora has flourished. (Courtesy of Ron Stewart.)

DINOSAURIOS ARGENTINOS
-Giants OF Patagonia-

U.S. Premiere
March 27 – Sept. 4, 2006
at

SciTech
Hands On Museum
18 West Benton
Aurora, IL 60506

SciTech, a hands-on museum, is located in the 1932 former Aurora Post Office building at 18 West Benton Street. The museum opened on June 16, 1990, and hosts over 60,000 visitors yearly. On display are more than 60 exhibits, including plastic pipe winds that demonstrate how sound travels, comparisons of tools and machines used in the Middle East during biblical times, a giant tornado exhibit, and a radar that tracks the speed of a baseball throw. (Author's collection.)

Marmion Academy hosted an exhibit of the work of Norwegian iconographer and art historian Solrunn Nes at its Dr. Scholl Exhibit Mezzanine on September 11–24, 2005. In her hometown of Bergen on the western Norwegian coast, Nes has created her own style of icon painting for the past two decades. Her paintings have been exhibited throughout Norway and western Europe as well as in Australia and Asia. Marmion Abbey relocated in 1952 on 330 sloping acres of Aurora. (Courtesy of Katie Brennan.)

The cultural relevance of the Schingoethe Center is to showcase Native American culture. Featuring more than 6,000 artifacts from 500 tribes, the center also has a variety of themed exhibits, a Native American film festival, an education gallery, and displays of Navajo rugs, silver, and turquoise jewelry. Opened in 1990, it is the legacy of Herb and Martha Schingoethe. Longtime collectors of these artifacts and arts from the indigenous peoples of the Southwest, they donated their collection to Aurora University and endowed Dunham Hall. (Courtesy of Dr. Michael Sawdey.)

Rachel Barton Pine, one of the world's most accomplished violinists, presented *A Tribute to Maud Powell's American Spirit* on October 23, 2005. Maud Powell was born on April 26, 1867, and lived in Aurora from 1870 to 1881. Powell was a child prodigy whose recitals included both folk songs and spirituals. In 1904, Powell was the first solo instrumentalist to record for the Victor Talking Machine Company. (Author's collection.)

A community breakfast was sponsored by the City of Aurora Hispanic Heritage Advisory Board to honor local youth on January 27, 2006. Mayor Tom Weisner introduced the winners of the art and essay contests as well as the Hispanic Youth Leadership and Service Awards. The Reverend David Engbarth received the Pete Perez Award. Marsha Jordan, an Emmy Award–winning writer and producer, gave the keynote speech. The Holy Angels Jazz Band provided the music for the 500 guests who attended. (Author's collection.)

The Midwest Literary Festival began in 2003 and has attracted thousands to downtown Aurora in celebration of the written word. Major sponsors of the festival include the City of Aurora, the Aurora Economic Development Commission, the Aurora Public Library, and the *Beacon News*. Agnes R. Kay published her song "Aurora Our Own" in 1925. The lyrics were true and contain these words: "As a symbol of light ever, our model city stands." (Author's collection.)

Jay Harriman, Jo Fredell Higgins, and John Jaros celebrate the completion of *Millennium Moments* history tapes of Aurora on October 26, 2000.

BIBLIOGRAPHY

Aurora As It Is. First annual gazette and directory. Aurora, IL: 1868.

Aurora Centennial Association, Inc. *Aurora Centennial 1837–1937.* Official historical program. Aurora, IL: 1937.

Aurora Life Magazine, Fall 1989.

Aurora Life Magazine, Fall 1990.

Aurora Life Magazine, Spring 1990.

Aurora Life Magazine, Spring 1991.

Bailey, John C. W. *Bailey's Directory of Kane County.* Kane County, Vol. II. February 25, 1867.

Barclay, Robert W. *Aurora 1837–1987.* Aurora, IL: 1988.

———. *Aurora . . . the City of Bridges.* Aurora, IL: 1955.

Beacon News. "Coulter House Made Debut in Aurora in 1874." September 15, 1946.

Beacon News. "Great Artists Have Appeared on Stage Here." September 2, 1931.

Brigham's Aurora directory, 1858–1859.

Chicago Herald Examiner, "Aurora's Part in the World War, 1918," May 14, 1918.

City of Aurora. Souvenir dedication book, police and court building. Aurora, IL: 1966.

Collins, David R., and Evelyn Witter. *Notable Illinois Women.* Milan, IL: 1976.

Coryell, Keith. *Entertaining Aurora: The History of Entertainment in Aurora, Illinois, Highlighted in Text and Pictures.* Carpentersville, IL: Crossroads Communications, 1993.

Cram's Universal Atlas, 1895.

Derry, Vernon. Edited by Mabel O'Donnell. *Aurora . . . in the Beginning.* Aurora, IL: 1953.

Edwards, Jim and Wynette. *Aurora.* Charleston, SC: Arcadia Publishing, 1998.

Edwards, Richard. *Aurora Census Report and Statistical Review.* Aurora, IL: 1872.

Holland's Aurora city directory 1880–1884. Chicago, 1880.

Holland's Aurora city directory 1884–18/87. Chicago, 1884.

LeBaron, Wm. Jr. *The Past and Present of Kane Co. Ill.* Chicago: 1878.

Medernack, John S. *Banking at the Corner of River and Downer.* The history of the Old Second National Bank. Aurora, IL: 1999.

Muhammad, Clayton. "Experience East, Experience Excellence." *Beacon News,* September 20, 2005.

Rolfe, Lyle. *Valley with a Vision.* Aurora, IL: 1998.

Thrift Corner Yarns, May-June 1967.

Waite, R., and Frank W. Joslyn. *History of Kane County, Ill.* Chicago: The Pioneer Publishing Company, 1908.

Weber, Chris Goerlich. *Faces & Places of the Fox Valley Area.* Aurora, IL: 1996.

ACROSS AMERICA, PEOPLE ARE DISCOVERING
SOMETHING WONDERFUL. *THEIR HERITAGE.*

Arcadia Publishing is the leading local history publisher in the United States. With more than 3,000 titles in print and hundreds of new titles released every year, Arcadia has extensive specialized experience chronicling the history of communities and celebrating America's hidden stories, bringing to life the people, places, and events from the past. To discover the history of other communities across the nation, please visit:

www.arcadiapublishing.com

Customized search tools allow you to find regional history books about the town where you grew up, the cities where your friends and family live, the town where your parents met, or even that retirement spot you've been dreaming about.